BODY AND SOUL

ANDREW
BUTTERFIELD
FINE ARTS

MORETTI

Florence – London – New York

BODY AND SOUL

Masterpieces of Italian Renaissance and Baroque Sculpture

Catalogue of an exhibition from October 21, 2010 to November 19, 2010

at

Moretti Fine Art

Adam Williams Fine Art

20 East 80th Street, New York, NY 10021

212 249 4987

Moretti Fine Art is also located

at

Piazza degli Ottaviani, 17/r, 50123 Florence

+39 055 2654277

43–44 New Bond Street, London W1S 2SA

+44 (0) 20 74910533

andrewbutterfield.com

morettigallery.com

Principal Photography by Maggie Nimkin

Design by Martin Schott

Printing by Polistampa, Florence, Italy

© 2010 EDIZIONI POLISTAMPA

Via Livorno, 8/32 - 50142 Firenze - Tel. 055 737871 (15 linee)

info@polistampa.com - www.polistampa.com

978-88-596-0828-8

BODY AND SOUL

MASTERPIECES OF ITALIAN RENAISSANCE AND BAROQUE SCULPTURE

CATALOGUE OF AN EXHIBITION

EDITED BY ANDREW BUTTERFIELD

ESSAYS BY

Andrea Bacchi

Andrew Butterfield

C.D. Dickerson

Marc Fumaroli

Giancarlo Gentilini

Tomaso Montanari

Riccardo Spinelli

ANDREW
BUTTERFIELD
FINE ARTS

MORETTI
Florence – London – New York

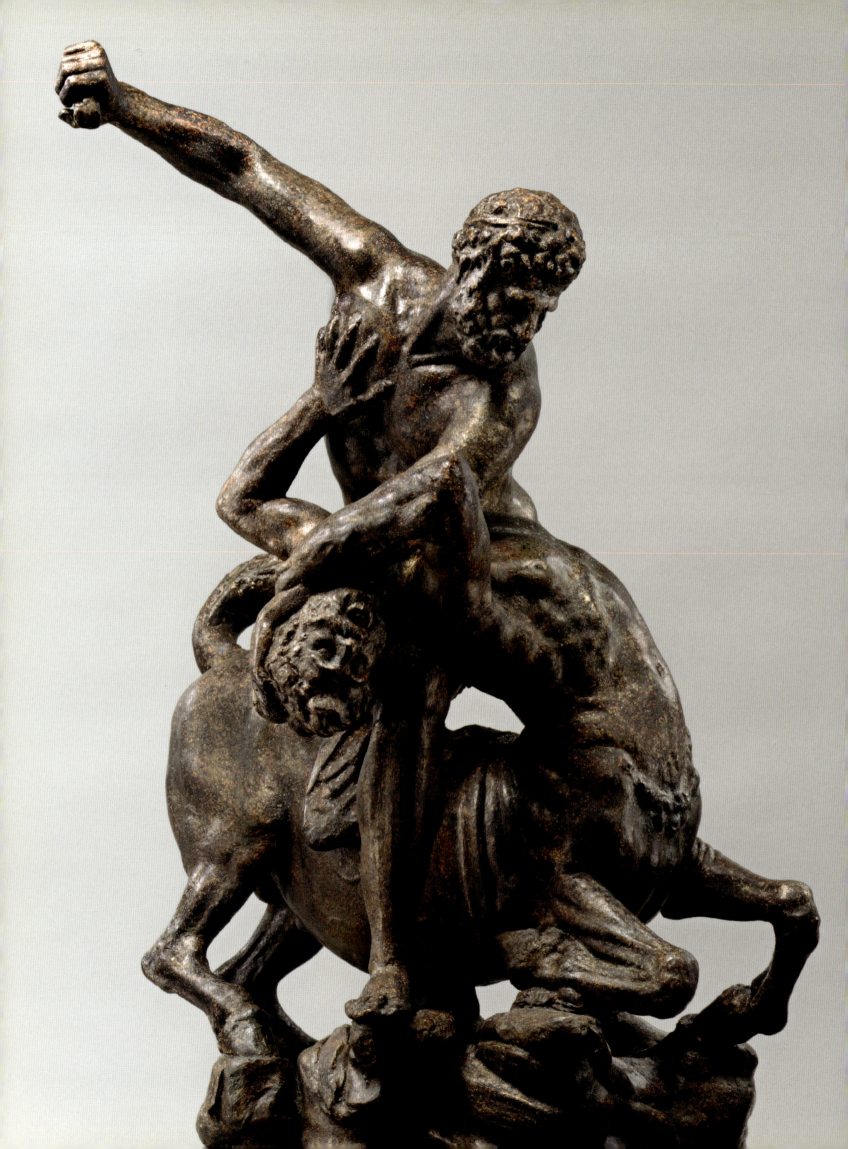

CONTENTS

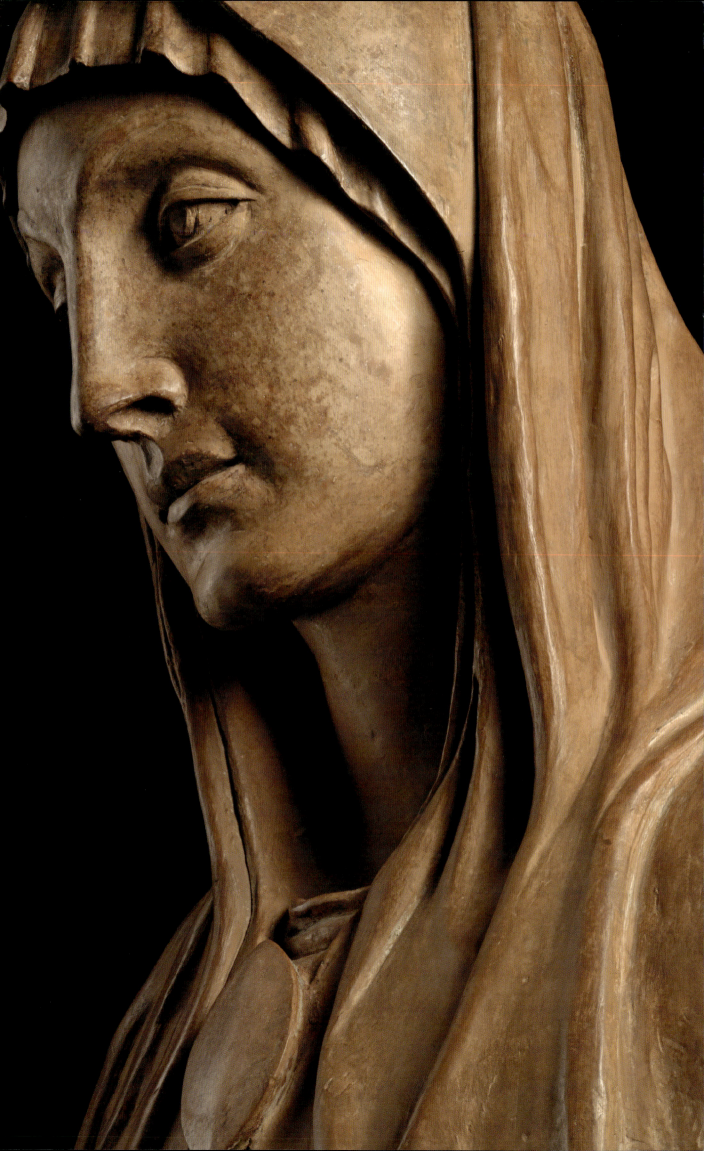

BODY AND SOUL

We are delighted to present *Body and Soul*, the first collaborative exhibition of Andrew Butterfield Fine Arts and Moretti Fine Art. We have joined forces to create this exhibition because of our deep commitment to the genius and beauty of Italian sculpture, and we hope to share this interest with a broad audience: connoisseurs, curators and historians, as well as the public at large.

As we aim to suggest by the title *Body and Soul*, the essence of Renaissance statuary was the desire to depict at one and the same time a realization of the human form combined with a manifestation of the human spirit. A painting is a picture of the world. But a sculpture is a thing, a body, a presence. All great sculptures present a body and show the animating sprit within. This ideal for statuary is found throughout time and all over the world, as the myth of Pygmalion and Galatea and comparable legends from so many cultures clearly demonstrate. Yet this magical ideal of sculpture was particularly prevalent in Italy during the Renaissance and Baroque. Vasari recounts that when finishing a statue for the Campanile, Donatello said to it "Speak! Speak, or may the plague strike you!" In a similar way, contemporaries wrote that Bernini could achieve the miraculous by making his marbles seem to speak — "facendo parlare i marmi." Of all the arts, sculpture came the closest to capturing the vital spark of life.

The works we have gathered in this exhibition, including sculptures by rivals and followers of Donatello and Bernini, such as Ghiberti, Riccio, Verrocchio and Algardi, combine ideality and naturalism of form with intensity and depth of expression. In these works the artists aimed to grasp not only the outer appearance but also the inner life of the figures they represent. The range of emotion depicted is extraordinary, from the peace and serenity of Sansovino's *Charity*—literally an embodiment of divine love—to the fear and anger of Verrocchio's *Head of a Gorgon*—a manifestation of Olympian terror.

One of the miracles of a great work of art is that the emotions the artist invested in it long ago continue to resonate and speak to us even today. This is especially true of masterpieces of Italian Renaissance and Baroque sculpture with their supreme and unwavering concentration on exterior beauty and interior spirit, presence and essence: Body and Soul.

Andrew Butterfield
Fabrizio Moretti

WHY NOT THE SUBLIME?

Andrew Butterfield reminds me of the many-sided and highly gifted Jacopo Strada (1515–1588), whom everyone in sixteenth-century Europe knew, whether they encountered him in Augsburg at the Fugger's home, or in Rome at Pope Julius III's court, or in Venice at Titian's studio, where the master did his famous portrait (now at the Kunsthistorisches Museum), or in Vienna, where Strada rounded out his life selecting and buying masterworks for the Habsburg collection. Strada was outstanding as draughtsman, painter, goldsmith, scholar, architect, art collector, and antiquarian. He is represented by Titian at the age of fifty, holding a classical marble statuette of Venus, while responding to an unseen and powerful customer or patron, perhaps the archduke Ferdinand, brother of Charles V.

Butterfield is known as an outstanding art-history scholar and a superb writer (virtues very rarely found together, but see his essays for the *New York Review of Book*s and elsewhere) and as a unique hunter of masterworks previously unknown and unpublished, worthy of the best museums. He will henceforth be also known as the head of a start-up art gallery, competing in its field of Renaissance and Baroque art with established and international companies. And it is typical of his insistence upon excellence that in this new venture he has chosen to collaborate in his first public exhibition, *Body and Soul*, with Fabrizio Moretti, an outstanding connoisseur and marchand d'art. Given Butterfield's scholarship and writing, you might think he would have sought to become a curator or director. But his decision to pursue the more challenging and free-form career of someone in the market is typical of the passions that drive him. I have rarely met a person with such a disinterested love of beauty and art, in the antique and Renaissance meaning of the words. He has the knowledge, the devotion, and the fire of the great collectors and enthusiasts. He wants the object of such a love to be loved, understood, treasured, honored. So, the museum or the market? Free to choose, he has chosen the market. Why? The art he loves is nowadays in competition for attention and success with a non-art that is extremely attractive to the non-loving and non-knowing. The frontline of this competition is in the market and not the museum-world. He will therefore fight for beauty on the battlefield of the market, a much harder fight now than in the times of Jacopo Strada, when beauty was universally sought after by the powerful and the rich, by popes and kings.

What sorts of things attract Butterfield's eye and mind? To understand, you have only to look through the present catalogue of sculpture, one marble, one bronze, the others in terracotta, the most immediate and spontaneous of materials, comparable for sculptors to what presentation drawings were for painters. All wonders, for the first time photographed and analyzed.

The head of an Apostle, or of John the Baptist, by the French Pïerre Le Gros, who finished his studies in Rome and never came back to France, is typical of the knack Butterfield has for artists uncharted by art history categories, who in spite of, or because of this neglect, reappear today in their intact genius. This head has the power of Michelangelo's *Moses*, and the fascination of Bernini's gods, and the magic of Puget. Seeing this extraordinary head, which communicates with such exceptional power, one understands why the artist stayed in Rome, instead of joining the art factory at Versailles of Le Brun and working alongside the correct and docile Girardon. There is in this head a life of its own; it is inhabited, you might say, with a presence of such commanding immediacy that you have to respond to it almost as to a living person. This is also the case of the previously unknown *Gorgon* here revealed to be by Verrocchio. It is the case, too, of the sinuous *Charity* by Sansovino, who overflows with life-giving energy and embodies what she is meant to represent—an outpouring of love and beauty. Cousin to the Baberini *Faun* and to the Borghese *Hermaphrodite*, the marble *Satyr Lying on a Panther's Skin*, from the less well known Domenico Pieratti, has such a fabulous erotic aura as to make Mapplethorpe look like a frightened puritanical artist. Other works are by artists up to now known chiefly by connoisseurs but deserving greater fame for their fantastic *furia* (Foggini) or their sense of the holy (Riccio, Mazzuoli), giving to the viewer the deep and lasting emotion of an encounter with everlasting beauty.

The works selected by Andrew Butterfield and Fabrizio Moretti have all the same hallmark: they ignore the ice of academicism—the conventions and formulas of the past as well as of today. They are torch-bearers of the sort of enhanced life of the senses and of the soul that the artists of the Renaissance and the Baroque—as much sorcerers and *magi* as painters and sculptors—were providing and are still providing. If you want to avoid the frigid images and dull objects typical of most periods and movements, whether contemporary or from the past, throw yourself into the shamanic embrace of the best of the Renaissance and Baroque. Why not the sublime?

Marc Fumaroli

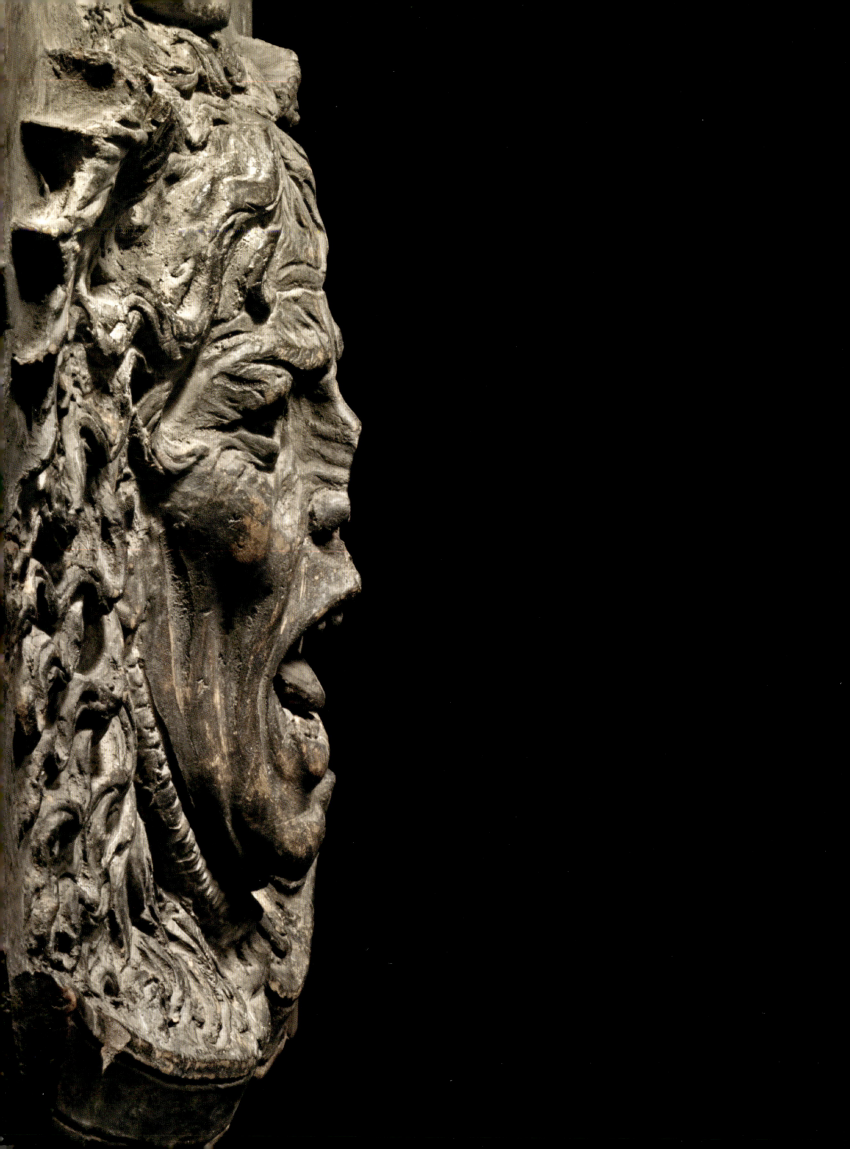

ANDREA DEL VERROCCHIO

ANDREA DEL VERROCCHIO
HEAD OF A GORGON

Terracotta, 30 by 39 cm. (11 ¾ x 15 ¼ in.), circa 1480

The rediscovery of a work by Andrea del Verrocchio (c. 1435–1488) is a major event in art history and it is made all the more important since its reappearance allows us to indentify a complete program of architectural sculpture by the artist that has never been previously recognized. The present work comes from the terracotta cladding formerly on one wall of a cortile of a palazzo in Rome located at Via dell' Arco de' Ginnasi, 23–25 (we thank Francesco Caglioti for this observation); the building was demolished in 1936 (fig. 1). Our sculpture, and one other relief of a gorgon's head, now in the Museo Archeolegico, Perugia, were detached in the nineteenth century. The other elements of the terracotta cladding were removed at the time of the house's destruction and are now in the Museo di Roma in the Palazzo Braschi.

The terracotta cladding consisted of the fascia and roundels of an arcade on the ground floor; the capitals and bases of the pilasters, and three window frames, including the pediments, of the *piano nobile*; the frieze of lion-heads and boughs above this story; the capitals and bases of the pilasters of the third story; and the frieze of gorgon heads and palmettes above this level. Our relief comes from this uppermost frieze (fig. 2), and it is one of the ten gorgon heads known to have been on the building.

The sculpture depicts the head of a gorgon *en face* to the viewer. The mouth is open as if shouting in terror, exposing the teeth and tongue. The eye sockets are wide as if staring; yet the sockets are hollowed out and were never filled. The hair of the gorgon shoots out to either side of the head in long thick locks. A pair of short batwings emerges from the upper portion of the head. Two snakes encircle the face; the heads of the snakes flare up

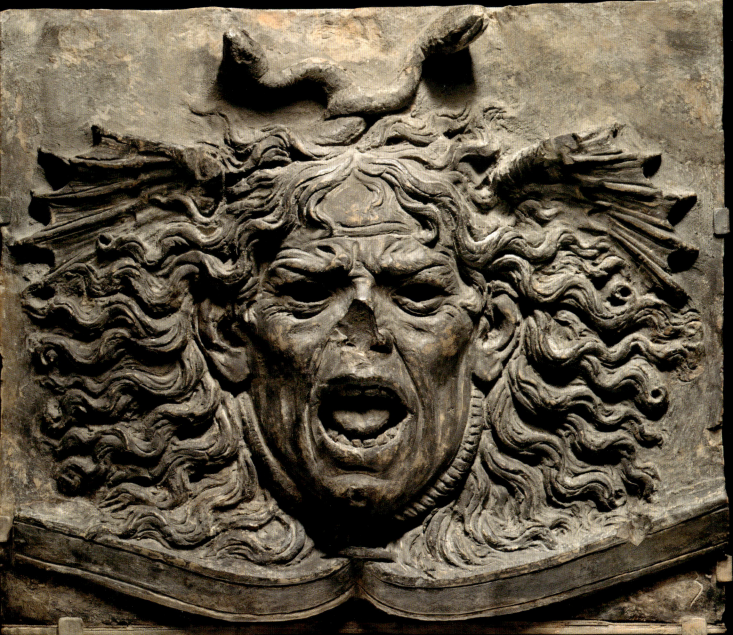

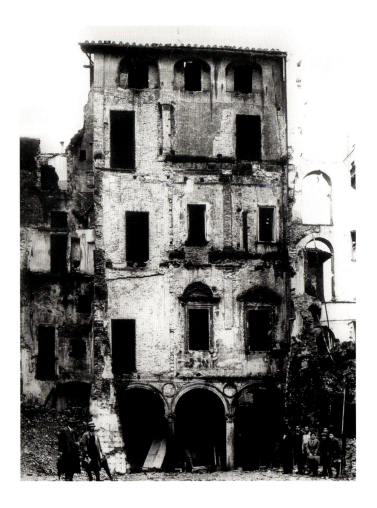

Fig. 1
Palazzo at via
dell'Arco de' Ginnasi,
23–25, Rome, during
demolition, 1936

and to the sides at the top center of the relief. Along the lower edge of the relief is a ribbon flowing to either side; this is joined together by a ring with several vertical indentations at the lower center of the relief below the chin of the gorgon. The ribbon was meant to link with the ribbon of the other panels so that they formed a line undulating all the way across the frieze.

Although the terracotta sculptures from the cortile of the palazzo have been published on several occasions, their date and authorship has not attracted much scholarly attention. Occasionally it has been suggested that they were made by the sculptor Gugliemo della Porta since he was the owner of the house in the sixteenth century. But one look at the comparable masks by della Porta on the tomb of Paul III in Saint Peter's is enough to show that such an attribution is mistaken. The evidence instead is overwhelmingly clear that Verrocchio was the author of this relief and the other elements of the facade's decoration.

One point of compassion is the terracotta Bust of *Giuliano de' Medici* (National Gallery of Art), and most especially the shouting head on the breast-plate of his armor. One should note the similar emphasis on exactly the same features of the face: the high cheekbones, the zygomaticus major and zygomaticus minor muscles of the cheeks, the creases in the forehead and around the eyes and eyebrows, and the wrinkles on the side of the bridge of the nose. Furthermore, in both works a decorative band or ribbon rises to an apex just below the chin. Also compare the volute above the head on Giuliano's breast plate with the volutes under the palmettes from the panels of the frieze. Also similar is the marble

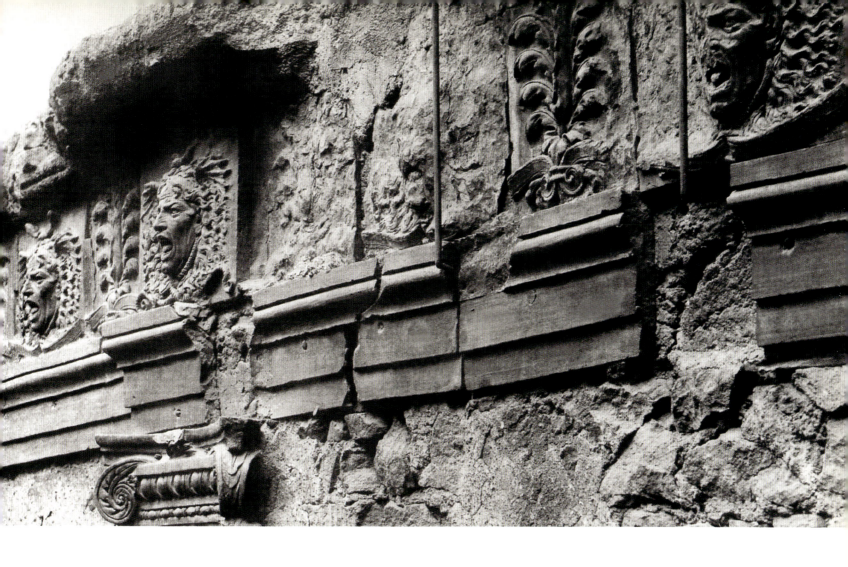

Relief of *Alexander the Great*, in the National Gallery of Art. The armor of this figure, too, is ornamented with a comparable shouting head, and the dragon wings of Alexander's helmet are shaped and decorated in a manner very much like that of the bat wings on the gorgon's head. Note as well the palmettes around the neck piece of the armor, which also correspond to the palmettes in the frieze.

Comparison with the bronze *Statue of David* in the Museo Nazionale del Bargello, Florence provides further evidence. Here the most striking points of comparison are with the head of Goliath that lies at David's feet. There is a strong formal resemblance of the hair on the forehead, the undulating crease in the forehead, and the wrinkles between the eyebrows of this head with the corresponding features of the gorgon relief. One should also observe the close similarity in the vigorous modeling of the interstices of the hair and comparable rhythm in the fall of the curls. The palmette on David's tunic, although inverted, has a design extremely like that of the palmettes in the frieze of the Roman palazzo; in both cases, along every leaf of the palmette there is a vein that runs near its outer edges in a comparable manner.

Another convincing point of reference is the shouting guard next to the tomb in the lower right of the terracotta relief of the *Resurrection* from the Medici Villa, Careggi (figs. 3, 5). Every component of his face corresponds in treatment with features of the present gorgon relief: the nearly identical tracks in the cheeks, the similar mouth, and creases around the eyes and between the eyebrows. The two faces are unmistakably alike.

Fig. 2
Verrocchio, *Frieze of gorgon heads and palmettes*, via dell'Arco de' Ginnasi, 23–25, Rome.

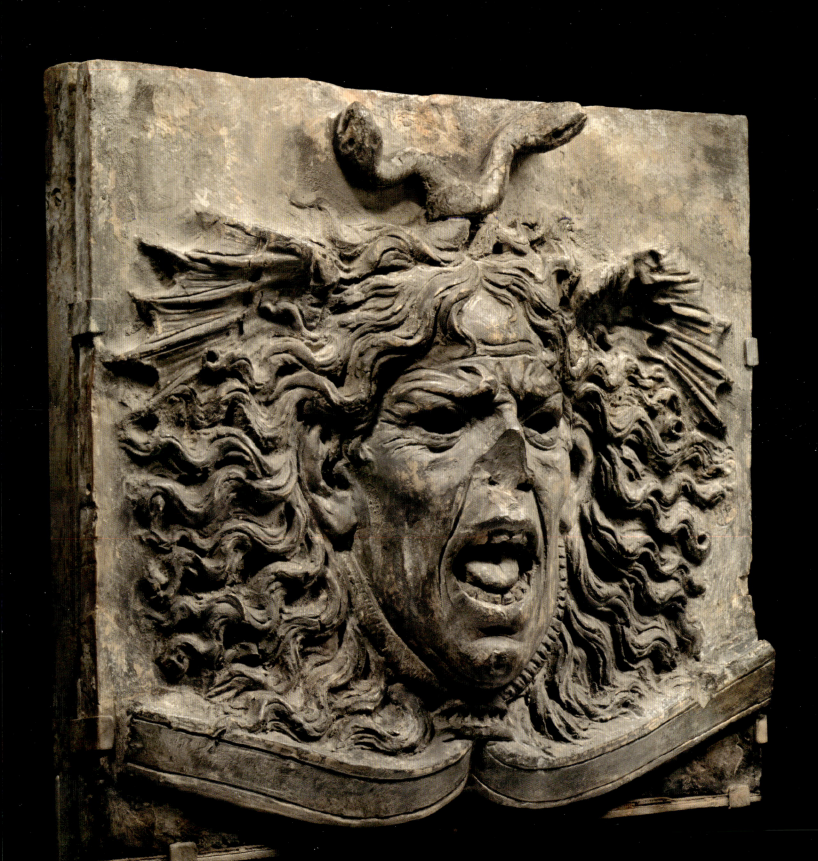

The silver *Beheading of St. John the Baptist* at the Museo dell'Opera del Duomo in Florence gives more proof. At the center of the silver relief two guards stand facing each other in angry confrontation (fig 4). Their faces are very much like that of the gorgon on the present terracotta relief. Observe in particular the similar treatment of the high cheekbones, and the similar treatment of the zygomaticus major and zygomaticus minor muscles of the cheek, as well as the comparable lines around eyes. The batwings on the helmet of the guard at the right resemble the batwings emerging from the gorgon of the present terracotta relief. Another striking detail to compare is the criss-cross pattern filled with circles and dots on the skirt of the guard at the left: this is identical with the detailing of the skin of the snake on the proper right side of the gorgon's face in the present relief. The palmette on the shoulder of this guard's armor is like that of the palmettes from the frieze in the cortile.

Similarities are also found in the *Equestrian Monument to Bartolomeo Colleoni* in Venice. The treatment of the creases around the eyes and eyebrows of Colleoni's head are like those of the present gorgon relief. More importantly one should look at the decoration of the sides of Colleoni's helmet, which shows a pair of ribbons or bands that rise together, and are bound near their apex with a decorated ring. This is extremely reminiscent of the design of the ribbon along the lower edge of the present relief.

The fall of the hair in the present work is also highly characteristic of Verrocchio. Strands of hair drape and curl across the forehead, and two locks that fall in agitated yet nearly

Fig. 3
Verrocchio,
Resurrection of Christ,
detail, Bargello,
Florence.

Fig. 4
Verrocchio, *Beheading of St. John the Baptist*, detail, Museo dell'Opera del Duomo, Florence.

Fig. 5
Verrocchio, *Resurrection of Christ*, detail, Bargello, Florence.

symmetrical disposition, somewhat like a pair of askew parentheses, are especially evident. There are many parallels for effects of this kind in Verrocchio's work, among them, the youth with the salver at the right in the Silver Relief, the angel at the lower left in the *Baptism of Christ* in the Uffizi, the head of Goliath in the *David*, the *Head of an Angel* drawing in the Uffizi, and the seraph at the foot of Jesus in the Forteguerri Monument (fig. 6), where the forms, although calmer as befits marble rather than terracotta, and in a work of completely different character, nevertheless follow much the same pattern.

The present relief was modeled by hand with great vigor and at considerable speed; the technique is masterly, deft, and assured. The tool marks, especially in the interstices of the hair, around the eyes, and in the tracks of muscle on the cheeks, show swift and commanding execution in the modeling of the clay. Study of the back of the relief, and comparison with the backs of the other reliefs as recorded in photograph, reveal enough differences to demonstrate further that these reliefs were not made in a mold, but worked individually.

The construction and ownership of the house in the fifteenth century is undocumented. (As already mentioned, in the mid sixteenth century, it belonged to the artist Gugliemo della Porta.) In style the terracotta elements are consistent with other buildings of the second half of the fifteenth century, both in Rome and Florence. It is noteworthy that the style of the arcade is more purely Brunelleschian in its reference to the design of the Spedale degli Innocenti then any other arcade in a building in Rome at this time. The

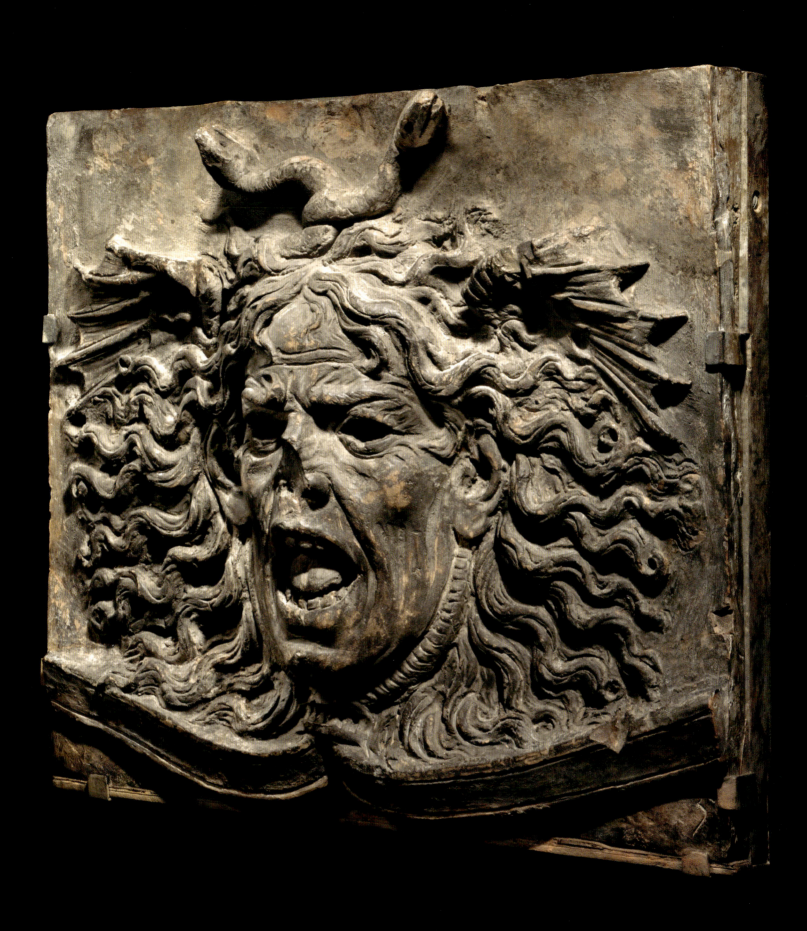

architecture also exactly corresponds with the architectural elements in the background of Verrocchio's Silver Relief.

The identification of the present sculpture and the related elements from the palazzo make the first solid point in the study of Verrocchio's activity in Rome, a subject that has perplexed art historians. In his life of the artist, Vasari reports that Verrocchio worked for Sixtus IV, making large silver statues of the apostles for the Sistine chapel, which unfortunately were stolen in the eighteenth century. Interestingly, many of the painters of the wall frescoes in the Sistine Chapel (1481-1483), such as Botticelli, Ghirlandaio, Signorelli and Perugino, had been students and assistants in Verrocchio's workshop in the 1470s. In addition, Vasari says that Verrocchio made a tomb for Francesca Tornabuoni (d. 1477) in Santa Maria sopra Minerva, Rome. However, no such tomb has been recorded in modern times. The present relief and the related elements in the Museo di Roma are a major addition to the corpus of Verrocchio.

Andrew Butterfield

BIBLIOGRAPHY

G. Bellucci, *Guida alle collezioni del Museo Etrusco-Romano in Perugia*, Perugia, 1910, p. 119, fig. 27a.

A. Butterfield, *The Sculptures of Andrea del Verrocchio*, New Haven, 1997.

A. Butterfield, "Renaissance Florence in the 1470s" [review of *Renaissance Florence, The Art of the 1470s*, exhibition at the National Gallery, London], in Apollo, 151, March 2000, pp. 59–60.

D. Covi, *Andrea del Verrocchio: life and work*, Florence, 2005.

N. Dacos, *La Découverte de la Domus Aurea et la Formation des Grotesques à la Renaissance*, London, 1969.

C. L. Frommel, *Der römische Palastbau der Hochrenaissance*, 3 vols., Tübingen, 1973.

U. Giambelluca, *La casa delle terrecotte alle Botteghe Oscure*, Rome, 2006.

P. Giordani, "Il Palazzo di Venezia e quello della Cancelleria in Roma," *Arte Italiana decorative e industriale*," n.s. IV, 1907, pp. 81–83, pls. 55–56.

G. Giovannoni, "La casa di Guglielmo della Porta," in *Bolletino del Centro Nazionale di Studi di Storia dell'Architettura*. Sezione di Roma, IV, 1945, p. 9.

W. Gramberg, "Guglielmo della Portas Grabmal für Paul III Farnese in S. Pietro in Vaticano," in *Römisches Jahrbuch für Kunstgeschichte*, XXI, 1984, pp. 253–364.

G. Marchetti-Longhi, "Le contade medioevali della zona 'in Circo Flaminio,'" in *Archivio della R. Società Romana di Storia Patria*, XLII, 1919, 3–4, 401–536.

G. Marchetti-Longhi, *L'area sacra del Largo argentina*, Rome, 1960, figs. 3, 31.

R. Marta, *L'Architettura del Rinascimento a Roma (1417–1503): techniche e tipologie*, Rome, 1995.

R. Marta, *Il Rinascimento a Roma fra Leon Battista Alberti e Donato Bramante*, Rome, 2004.

O. Mazzucato, "Il palazzetto delle terrecotte," in *Ceramica per l'architettura*, VIII, 1994, pp. 12–19.

B. Nogara, "Una medusa del Rinascimento nel Museo Civico di Perugia," in *Studies presented to David Moore Robinson on his seventieth birthday*, Saint Louis, 1951, vol. I, pp. 796–800, pls. 101-102.

C. Pietrangeli, *Rione IX-Pigna, Giude rionali di Roma*, Rome, 1977, part I, pp. 26–27.

A. Proia, P. Romano, *Roma nel Cinquecento. Pigna (IX Rione)*, Rome, 1936, p. 118.

A. Schiavo, *Il Palazzo della Cancelleria*, Rome, 1964.

Sisto IV e Giulio II: mecenati e promotori di cultura: atti del convegno internazionale di studi, Savona, 1985, Savona, 1989.

Sisto IV: le arti a Roma nel primo Rinascimento: atti del Convegno internazionale di studi, ed. by F. Benzi, Rome, 2000.

JACOPO SANSOVINO

JACOPO SANSOVINO
CHARITY

Terracotta, 59 cm. (23 ¼ in.) high, circa 1513

The present terracotta is one of the most important discoveries in Renaissance art in decades. It is by Jacopo Sansovino (1486–1570), among the leading sculptors of the sixteenth century, and one of the few artists to flourish in all three of the main capitals of Renaissance art: Florence, Rome, and Venice. A protégé of the sculptor Andrea Sansovino and the architect Donato Bramante, Jacopo came to artistic maturity under the aegis of Raphael. Indeed, as observed by John Pope-Hennessy, no sculptor was more Raphaelesque than Jacopo. On moving to Venice, Jacopo also became a close friend of Titian. He, Titian, and their friend Pietro Aretino formed the triumvirate that dominated art in Venice for much of the sixteenth century.

In his *Life* of Sansovino, Giorgio Vasari stresses the originality, importance, and fame of the sculptor's models, whether in wax or terracotta. Pope-Hennessy has also emphasized this point, writing: "Models embody sculptural ideas, and Sansovino's significance and stature are due to the ideas which, over his long life-span, he generated" (Pope-Hennessy 1994, p. 186–87). His models were collected and praised by major patrons, including Pope Leo X and Domenico Grimani, and were also commissioned and copied by painters. Vasari mentions Perugino, Luca Signorelli, Bramantino, and others as turning to Sansovino for models for their works. It has also been suggested that Lorenzo Lotto and Titian did so as well (Pope-Hennessy 1980, pp. 331–32). According to Vasari, the most prominent example of Jacopo's friendship with, and assistance to, a painter was Andrea del Sarto, a point that now receives resounding confirmation with the rediscovery of the *Charity*.

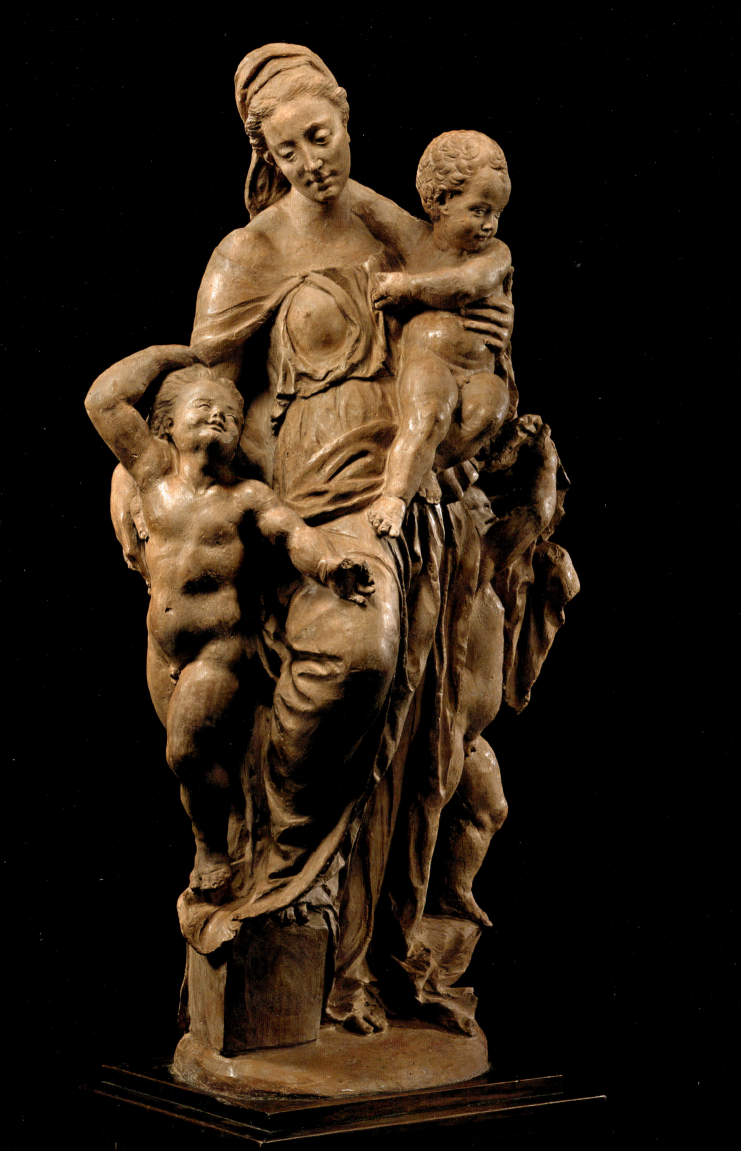

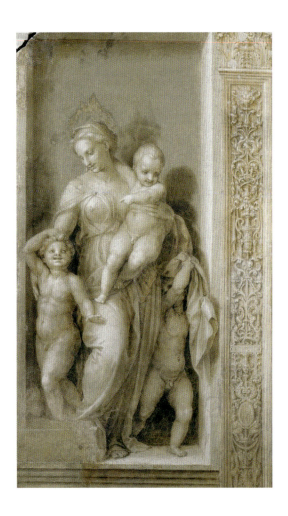

Fig. 1
Andrew del Sarto,
Charity, Chiostro
dello Scalzo, Florence

Of all Sansovino's surviving models—fewer than ten can be confidently ascribed to him—none is nearly as masterful as the *Charity*. Its technique is assured and vibrant; its design is spectacularly original; and its condition is superb. The *Charity* proves beyond question that among Sansovino's greatest contributions to art were his models and the ideas that they conveyed.

The *Charity* can be dated to around 1513, the approximate year in which Andrea del Sarto executed his fresco of Charity in the Chiostro dello Scalzo, Florence, for which the terracotta served as the model (fig. 1). No sculptor was closer to Sarto than Sansovino. They occupied workshops in the same building across from the Annunziata; they collaborated on prestigious projects, including the temporary facade for Florence Cathedral raised in honor of Pope Leo X in 1515; and they were constantly turning to the other for ideas. According to the available evidence, which includes Vasari, Sarto gave Sansovino regular access to his drawings in exchange for the privilege of studying his friend's models—often with the intent of using them in his paintings as the basis for individual figures. In his *Life* of Sansovino, Vasari writes:

> Now, Jacopo beginning to exercise his hand, he was so assisted by Nature in the things that he did, that, although at times he did not use much study and diligence in his work, nevertheless in what he did there could be seen facility, sweetness, grace, and a certain delicacy very pleasing to the eyes of artists, insomuch that his every sketch, rough study, and model has always had a movement and a boldness that Nature is wont to give to but few sculptors. Moreover, the friendship and in-

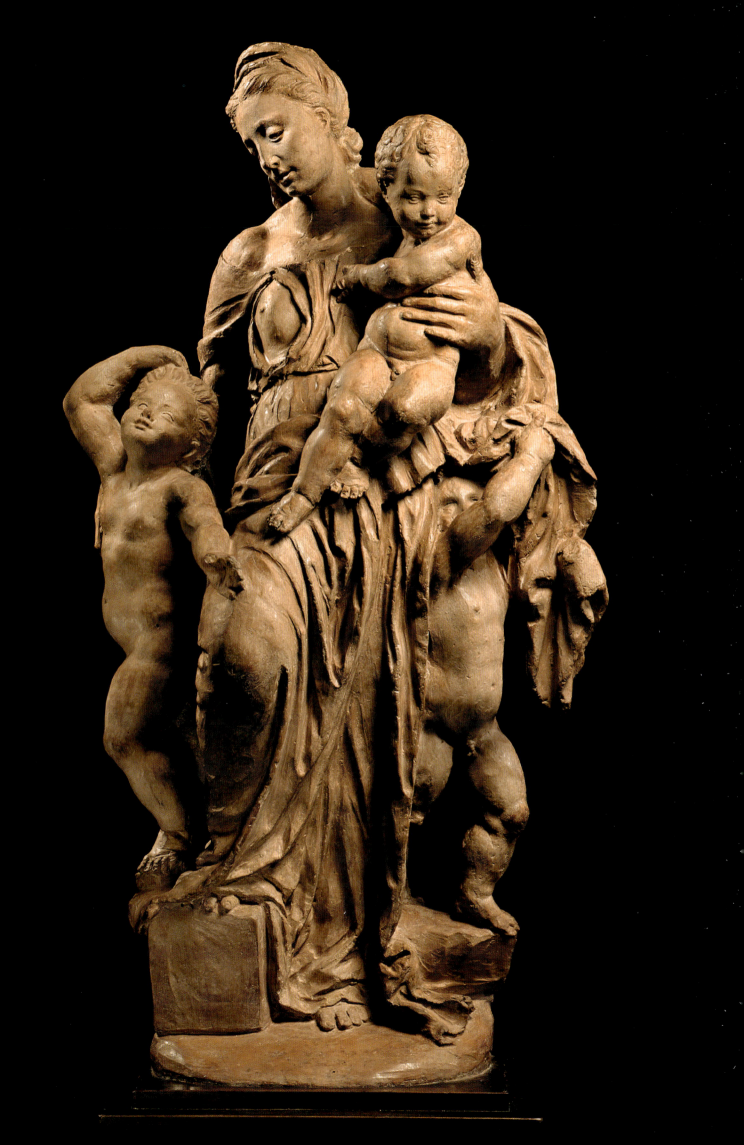

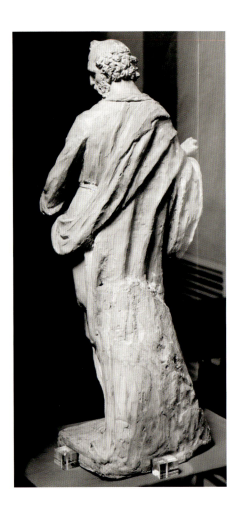

Fig. 2
Jacopo Sansovino,
*Saint John the
Evangelist*, Musée
Jacquemart-André,
Paris

tercourse that Andrea del Sarto and Jacopo Sansovino had with each other in their childhood, and then in their youth, assisted not a little both the one and the other, for they followed the same manner in design and had the same grace in execution, one in painting and the other in sculpture, and conferring together on the problems of art, and Jacopo making models of figures for Andrea, they gave one another very great assistance. (Vasari 1563 (ed. 1996), vol. 2, p. 804)

As Vasari was a pupil of Sarto, and a friend of Sansovino, his account of their artistic relationship was especially well informed. Vasari mentions a specific case regarding Sarto's celebrated *Madonna of the Harpies* (Galleria degli Uffizi, Florence). Sarto derived the figure of Saint John the Evangelist from a model of the same subject (now lost) that Sansovino had made a year or two before. The practice seems to have been fairly regular for Sarto. A scan of his paintings from the 1510s (including others in the Chiostro) reveals many figures that look distinctly sculptural and that are widely thought to reflect lost models by Sansovino. These would have included models that Sansovino had made for his own use, as well as ones that were special orders, models that Sansovino made as a favor to his friend in order to help him to solve a specific compositional problem. There is an important precedent for this second type of model in Sansovino's career. While living in Rome around 1508, he is reported to have so impressed Perugino with his models that the painter asked him to produce some that he could use in his paintings.

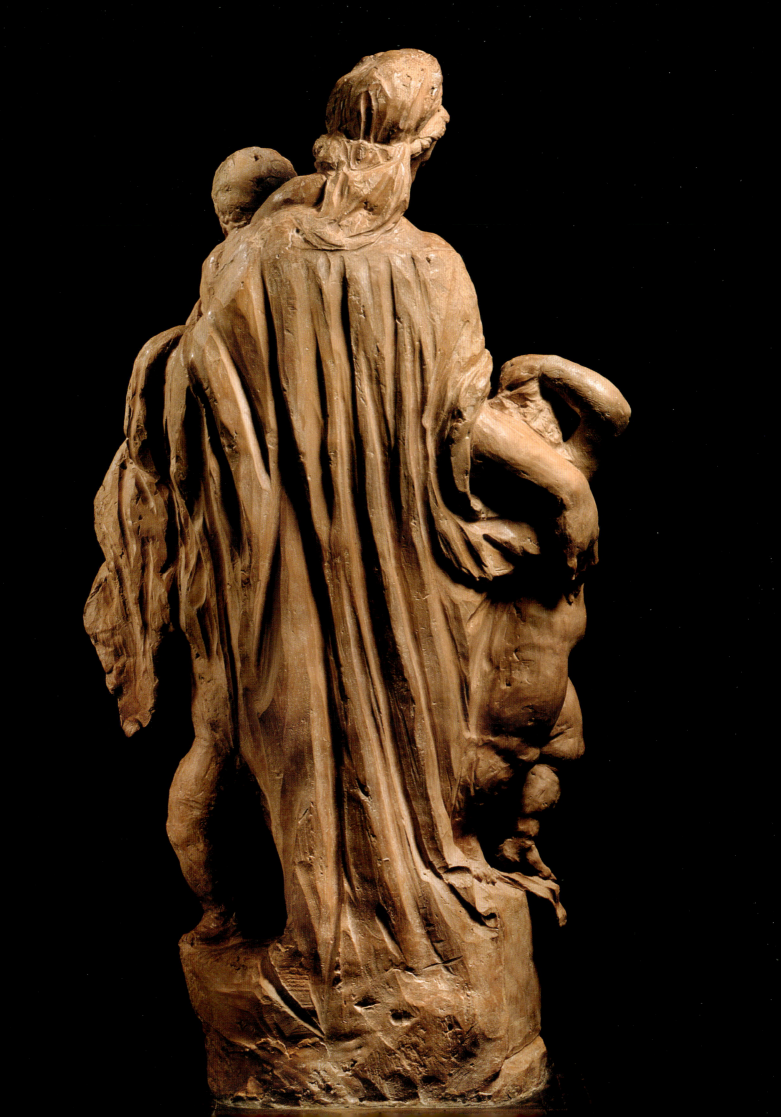

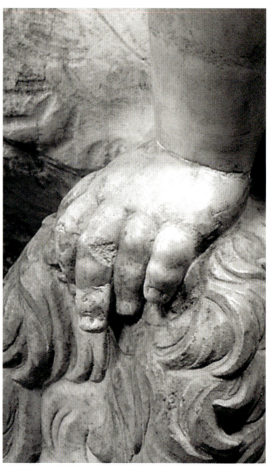

Fig. 3
Jacopo Sansovino,
Charity, detail

Fig. 4
Jacopo Sansovino,
Bacchus, detail

The hypothesis that the *Charity* is by Sansovino and was preparatory for Sarto's fresco of the same theme in the Chiostro rests on much firmer ground than circumstantial evidence. First, the *Charity* cannot be a later copy of the fresco, since the differences between the two works indicate that the painting was based on the sculpture, not vice versa. If we look at the sculpture from head on and compare this view to the fresco, we recognize that the fresco combines at least two different views of the sculpture. One is quartering from the left, while the other is directly from the front. In the fresco, the child on the left and *Charity's* lower right leg reproduce the view that we gain by rotating the sculpture about forty-five degrees counterclockwise. For the rest of the fresco, Sarto has returned the model to its primary view and, in the process, shifted the child on the right outward. He has also taken this child off his small pedestal, and we now see his entire right leg. Finally, Sarto has given Charity a flaming crown to reinforce her identification; there is also evidence that he inserted a small urn next to the child on the left.

The other differences between the sculpture and the fresco are primarily stylistic, yet these too indicate the primacy of the sculpture. The drapery in the fresco is less faceted, and the faces of the figures are broader through the cheeks and bear wider smiles. While a copyist making a statue might allow these minor discrepancies in style to infiltrate his or her copy, the same copyist would never think to compress the fresco's composition by moving the left child backward and shifting the right one upward and inward. These changes only make good sense if they happened in reverse, with Sarto adjusting the model's composition to meet the demands of painting.

When Sarto was given the model, he doubtlessly studied it from different angles, all the while considering which parts would suffer in the translation from three dimensions into two. His answer was the side figures, which he brought outward and forward to improve their legibility from the front. An unintended consequence is that the forms in the fresco became flatter, more like those of a relief and less like a sculpture. It is assumable that any sculpted copy would reflect this quality. The *Charity* does not. It is too strongly three-dimensional. Clearly, it was originally conceived as a sculpture, not adapted from a painting or a drawing.

Proof that the *Charity* is by Sansovino are the many technical and stylistic correspondences that it bears with his accepted works. One of the most revelatory pertains to the back. Knowing that the sculpture was preparatory for something that would not be seen in the round, Sansovino treated the back summarily, although in a style that was distinctly his own. Running up and down the back is a series of wide, deep gouges that are used to suggest the drapery. Where these gouges come to termini, they tend to be gradually tapered. They are also V-shaped in profile, suggesting that they were created with an oval tipped modeling tool pulled through the clay from top to bottom. Markings of similar character appear on the backs of some of his other sculptures, including *The Nichesola Madonna*, a bronze Virgin and Child in the Cleveland Museum of Art. While its back is more carefully worked than the *Charity's*, there are definite similarities with the pleats on the upper half—especially the two running over her shoulder blades.

Fig. 5
Jacopo Sansovino, *Charity*, detail

Fig. 6
Jacopo Sansovino, *Bacchus*, detail

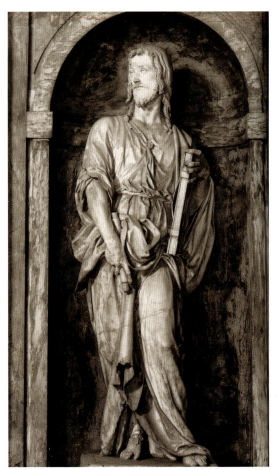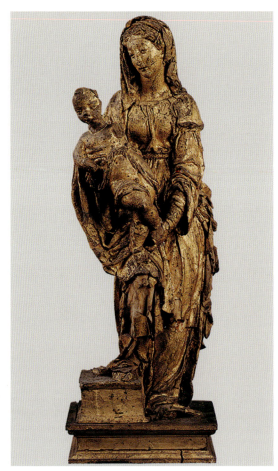

Another sculpture that is relevant in this regard is a terracotta Saint Paul in the Musée Jacquemart-André, Paris (fig. 2). Sansovino is thought to have modeled this figure a year or two before the *Charity*. As with the *Charity*, the back of the *Saint Paul* is unfinished. Sansovino's only attempts to articulate it came in the form of the same crude gouges that appear on the *Charity*. Although they are fewer in number and run diagonally, there is no disputing that they are of an identical character to those on the *Charity*. It is also noteworthy how Sansovino, in working down the back of the *Saint Paul*, gave up at a certain point. On the *Charity*, the lower third of the back is virtually untouched compared with the upper third—especially in the area of the veil, which is beautifully worked in a quick, impressionistic manner.

Turning to the front of the terracotta, the idiosyncrasies in style continue. The fingers of the children are uniformly short and pudgy, and the hands are of similar character, wide and boneless (fig. 3). This is a type that appears consistently in Sansovino's child figures; a good example is the young faun in his marble *Bacchus* (fig. 4). Even with the expanded scale of the marble, the only substantial change to the hands is the addition of cuticles. The left hand of the child in *Charity's* arms reflects a similar style of abbreviation. He grabs at the drapery between her breasts with nothing but nubs, and it is noteworthy how the fingers in play are the thumb, the index finger, and the ring finger. A hand in a similar pose and that also fidgets with drapery can be located on at least one other figure in Sansovino's oeuvre, the Christ Child in the Vittorio Veneto type of his Virgin and Child relief, of which a good example is in the National Gallery of Art, Washington, D.C.

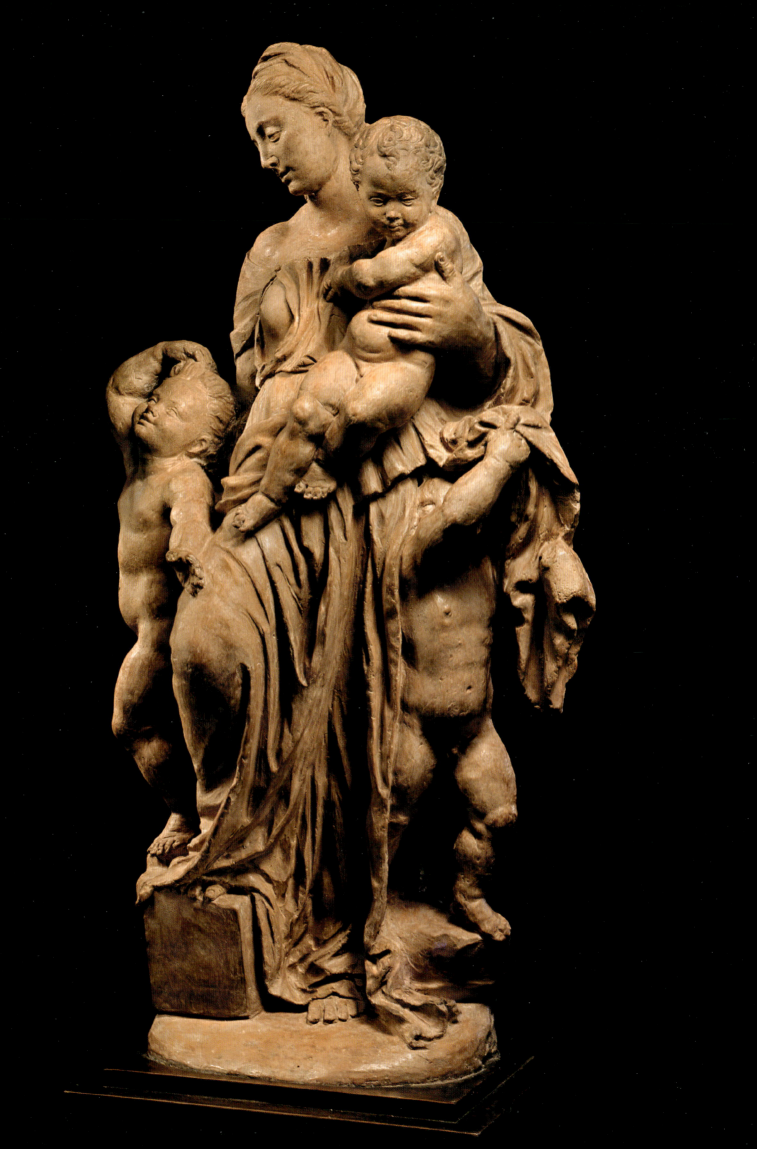

Drapery is another place where Sansovino's individual style stands out clearly. In the fresco, Sarto has taken a more restrained approach, while the drapery on the terracotta gathers and flows in more active patterns. Here, the edges of the cloth fall in shimmering waves (not in straight lines), and there is enormous variety in the rhythm and the character of the pleats. Some—like the one to the right of *Charity*'s bent knee—are gentle and S-shaped, while others are sharper and more energized—as with the passage between her feet.

The 1510s saw Sansovino's drapery style pass through its liveliest phase. Other than the *Charity*, the best example is his virtually contemporaneous *Saint James the Greater* in Florence Cathedral (fig. 7). The treatment is similarly lavish, with intricate bunches of fabric and spirited sweeps of cloth, such as the one that goes under his right arm and loops at his middle. In some places, the handling of the drapery is nearly identical. On Charity's proper right just beneath her breast, where one layer of cloth gathers over another, is a series of ripples. The *Saint James* bears a similar pattern in an analogous location: where his mantle folds over itself above his waist. The *Saint James* can also be related to the *Charity* in the way that the bottom edge of the mantle is subtly articulated. Rather than leaving it flat, Sansovino has given it a faceted quality that recalls the delicate texturing applied to the leading edge of the cloth that descends down the right side of the child on *Charity*'s left. Another sculpture that is thought to come from Sansovino's second Florentine period is the wood, linen, and stucco *Virgin and Child* in the Szépművészeti Múzeum, Budapest (fig. 8). Although the sculpture is badly damaged, it bears many similarities with the *Charity*, especially the pooled drapery at the feet.

Other parallels with Sansovino's securely autograph works can be readily found. The raised right arm of the child on the left (fig. 5) recalls the seated faun at the base of the marble *Bacchus* (fig. 6). This child also invites comparison with Bacchus himself for his lifted head and joyous expression. Even the placement of the child's feet (one behind the other and on cloth) is typical of Sansovino. It recurs on his later terracotta *Virgin and Child with Infant Saint John the Baptist* beneath the Loggetta, Venice. Another characteristic motif of Sansovino was to show *putti*, child angels, and other children playfully lifting drapery over their heads and peeking out from beneath it. The child on *Charity*'s proper left engages in this activity. Comparable figures abound in Sansovino's oeuvre, such as the angel on the left in his *Virgin and Child* in the Chiesetta of the Doge's Palace, Venice. The child on Charity's left is also noteworthy for the position of his legs. The open stance, which serves to break up the composition and add movement, is relatively frequent in Sansovino's sculptures, as with the standing child on his much later *Charity* in San Salvatore, Venice.

Many of the features discussed above reflect specific sources to which Sansovino often turned. The raised arm over the head can be connected to the *Laocoön*, a sculpture with which Sansovino had a strong and early connection. According to Vasari, while Sansovino was working in Rome prior to 1510, he won a competition judged by Raphael for the best wax model of the recently excavated group. Part of the challenge of the competition was

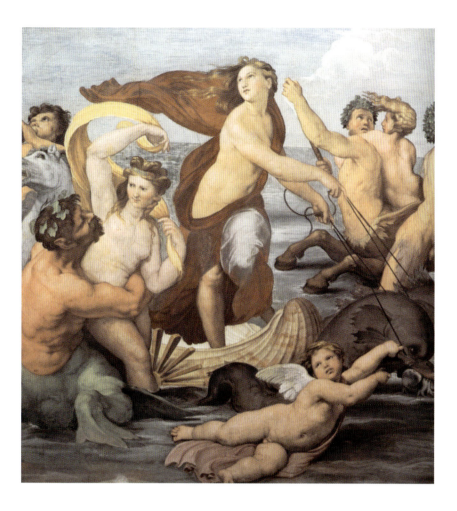

Fig. 9
Raphael, *Galatea*, detail, Villa Farnesina, Rome

to imagine how the statue should be restored. At the time, *Laocoön* lacked his right arm, as did his younger son. Although Sansovino's winning model is lost, a sheet in the Musée du Louvre, Paris, suggests that he favored giving the younger son a raised arm bent back over his head at the same acute angle as the corresponding arm on the *Charity* (Boucher 1991, vol. 2, p. 377, no. 130).

The *Laocoön* also led Raphael to consider the expressive potential of raised arms over heads. This is clear from any number of his paintings and drawings, including the two children appearing in his *Philosophy* on the ceiling of the Stanza della Segnatura (Musei Vaticani, Vatican City). The precedents in Raphael's art for the raised arm would have weighed heavily on Sansovino's mind as he composed the *Charity*. Raphael may also lie behind the open stance of the child on Charity's left. The idea may have sprung from Raphael's aforementioned *Philosophy*, which Sansovino would have had a chance to study before moving back to Florence around 1511.

The Charity herself is distinctly Raphaelesque in other ways. Among the most obvious is the pose of *Charity*, an early example of the *figura serpentinata* that Raphael was then exploring in such precisely contemporaneous paintings as his *Saint Catherine of Alexandria* (National Gallery, London), *Galatea* (fig. 9; Villa Farnesina, Rome), the figure of Parmenides in his renowned *School of Athens* (fig. 10), and a woman with children on the ceiling of the Stanza d'Eliodoro. The parallels with Charity are especially obvious with Parmenides. Like him, she raises one foot on a block, assumes a gentle sway, and turns her head to the side.

Her attitude is relaxed, although full of potential movement. Raphael's exploration of the *figura serpentinata* was prompted by Michelangelo's revolutionary but unfinished *Saint Matthew*, with its powerfully contorted and unbalanced pose (Galleria dell'Accademia, Florence). Raphael sought a more graceful and sinuous turning of the body. Sansovino followed his lead in developing an ideal of artistry that emphasized *grazia* rather than *terribilità*.

A further debt that the *Charity* pays to Raphael is in the body type of the children. In keeping with Raphael, Sansovino has given the children plump, fleshy proportions and thought carefully about the effect of movement on their anatomies. One example will suffice to demonstrate how the type persisted in his art. On his much later Chiesetta *Madonna*, the forward angel on the left has the same underlying structure as the left child on the *Charity*. In addition to the plump, swollen legs, even their rib cages are similar.

That the *Charity* is among the most Raphaelesque sculptures ever made becomes a distinct possibility when we consider her face. It is one of the most sensitive portrayals of a female in all of Renaissance sculpture—and this includes the Virgin in Michelangelo's *Pietà* in St. Peter's. Lowering her head gently to her right, she meets the dreamy gaze of the child on that side. Her mood seems instantly to brighten, as a smile of maternal love crosses her face. Every feature speaks tenderness—from the dimples at the sides of her mouth to her partially shut eyelids to the smooth and rounded contours of her cheeks, nose, and chin. This is not the severe idealism of an ancient Roman sculpture of a goddess. Rather,

it reflects Raphael, as demonstrated by such paintings as his *Saint Catherine of Alexandria*. Not only does *Charity* exhibit the same qualities of purity and sweetness; she is also invested with a comparable degree of life-likeness.

By looking to Raphael, Sansovino succeeded in breathing new life into an old iconographic formula. Charity, which encapsulates the concept of unstinting love, is the third and greatest of the theological virtues. During the Renaissance, it was commonly symbolized as a woman with a nursing child or children. In some representations, she holds a flame or a basket of fruit. While Sansovino did not upend this tradition, he went to greater lengths than any artist before him to cast his *Charity* as a beautiful woman. The sculpture conveys a humanity that was new to the iconography, and other artists—not just Sarto—paid attention. Images of Charity became especially popular in Florence after the mid-1510s, and one reason is likely to have been Sansovino. His model—and the fresco that it inspired—showed how the subject could be treated in a compelling, modern way.

The *Charity* pushes the limits of sculpture. The complicated textures, the deep and overlapping pleats, and the many places where the composition is pierced and modeled in the round would have defied easy translation into bronze or marble. It is therefore appropriate that the *Charity* should be in clay and intended for a painter. Its purpose was to convey a visual idea. Later sculptures of Charity—including many that bear Sansovino's influence, such as Giambologna's bronze *Charity* in the Palazzo Spinola, Genoa—make compromises for their materials. The *Charity* does not. It is an exercise in distilling the essence of the High Renaissance. It was at moments like this, when the practicalities of sculpture did not matter, that Sansovino was at his best, a pure visual thinker.

C.D. Dickerson

BIBLIOGRAPHY

Bruce Boucher, *The Sculptures of Jacopo Sansovino*, New Haven, 1991.

Sydney Freedberg, *Andrea del Sarto*, Cambridge, Mass., 1963.

John Pope-Hennessy, "The Relations between Florentine and Venetian Sculpture in the Sixteenth Century", in *Florence and Venice: Comparisons and Relations*, Florence, 1980, vol. 2, pp.323–35.

John Pope-Hennessy, "Sansovino", in *On Artists and Art Historians, Selected Book Reviews of John Pope-Hennessy*, Florence, 1994, pp. 186–190.

John Pope-Hennessy, *Italian High Renaissance and Baroque Sculpture*, fourth edition, London, 1996, pp. 121–129.

John Shearman, *Andrea del Sarto*, Oxford, 1965.

Giorgio Vasari, *Lives of the Painters, Sculptors and Architects* (1563), translated by Gaston du C. de Vere, with an introduction and notes by David Ekserdjian, 2 vols., New York, 1996, esp. vol. 2, pp. 803–37.

ANDREA
RICCIO

ANDREA RICCIO
MADONNA DOLOROSA

Terracotta, 65 cm. (25 ¾ in.) high, made circa 1500–1510

"Don't think she wept, as others say . . . and don't think that she went about crying, disheveled and unkempt, for she was able to command the sensitive part of her soul so that she suffered, but she was not only sad, but happy and sad, in a way that made people marvel because she did not act as other mortals do . . . She was happy and sad, profoundly amazed by the immense mystery and the great benevolence of god."

These words from the *Prediche sopra Amos* of Girolamo Savonarola with which he described in 1496 the Sorrow of the Virgin at the foot of the cross can help us to understand the subject, and to contextualize the function, of this rare unpublished bust in terracotta. It represents the Mater Dolorosa, the sorrowful Virgin, a subject which would have a particularly wide diffusion in seventeenth-century sculpture, often with an acutely expressive and dramatic depiction of feeling, above all in Spain, as demonstrated by the wooden bust by José de Mora, now in the Victoria and Albert Museum, to choose only one of the most celebrated examples (M. Trusted, *Spanish Sculpture, A Catalogue of the Collection in the Victoria and Albert Museum*, London, 1996, pp. 103–106). Although of a different country and date, it resembles the present sculpture in its controlled yet compassionate mood. Works of this kind are also found in earlier periods in European art, for instance, a Flemish bust in terracotta of this subject, formerly in the Thyssen collection, and dated around 1470 to 1490. (M. Maeck Gérard, in A. Radcliffe, M. Baker and M. Maeck Gérard, *The Thyssen Bornemisza Collection. Renaissance and later sculpture*, London, 1992, pp. 418–423). The present work is characterized by a degree of austerity and ideality of a decisively classical style, and together with a sympathy for Savonarolan spirituality, this

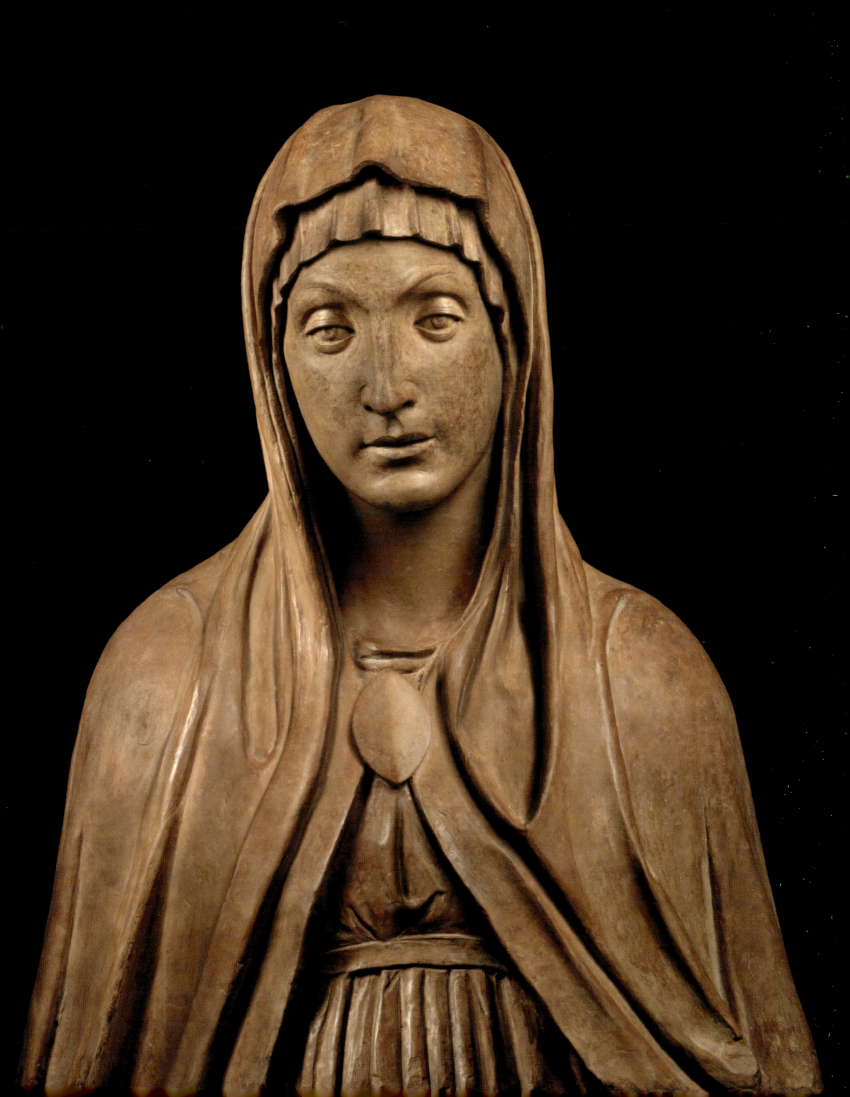

Fig. 1
Andrea Riccio, *Story of the True Cross*, detail, Galleria Giogio Franchetti alla Ca' d'Oro, Venice.

Fig. 2
Andrea Riccio, *Story of Judith*, detail, Basilica del Santo, Padua.

makes it immediately clear that it comes from Italy around 1500, and in particular, Padua, which was so strongly imbued with the memory of Greco-Roman antiquity.

The physiognomic traits of the head are here distilled with an absolute sense of form that helps create a face of ideal purity: as few other sculptures, it combines restricted formal means, and deep emotional expressiveness, geometry and poetry. There is power and immediacy in the rapt and melancholy meditation of the figure. Yet clear regularity of form characterizes the geometric perfection of the line of the nose, the arch of the eyebrows, the elongated shape of the eyelids, which the artist defined with almost metallic rigor, as if carved with a chisel, and the nearly imperceptible, yet very moving, parting of the lips. The bust is frontal in orientation, and the face is enveloped by a mantel with nearly parallel folds that are only slightly varied and dented. She is a figure of exalted *gravitas*.

Unmistakably, the sculpture reveals the characteristics typical of the sculptures of Andrea Riccio (c. 1470-1532), one of the most important and most celebrated interpreters of humanistic culture in Venice and Padua during the High Renaissance. The distinguishing features of his masterpieces in bronze were almost unchanging in his career: throughout one sees the same physiognomy of the head, marked by the elongated oval of the face, the emphatically sharp nose, the slim profile of the eyes, and the almost impassive, yet highly expressive, treatment of emotion, inspired by classical sculpture. We find these characteristics in the figures of Saint Helen and her followers in the reliefs of the *Story of the True Cross* made around 1500-1505 for the church of the Servi in Venice (fig. 1; see Gas-

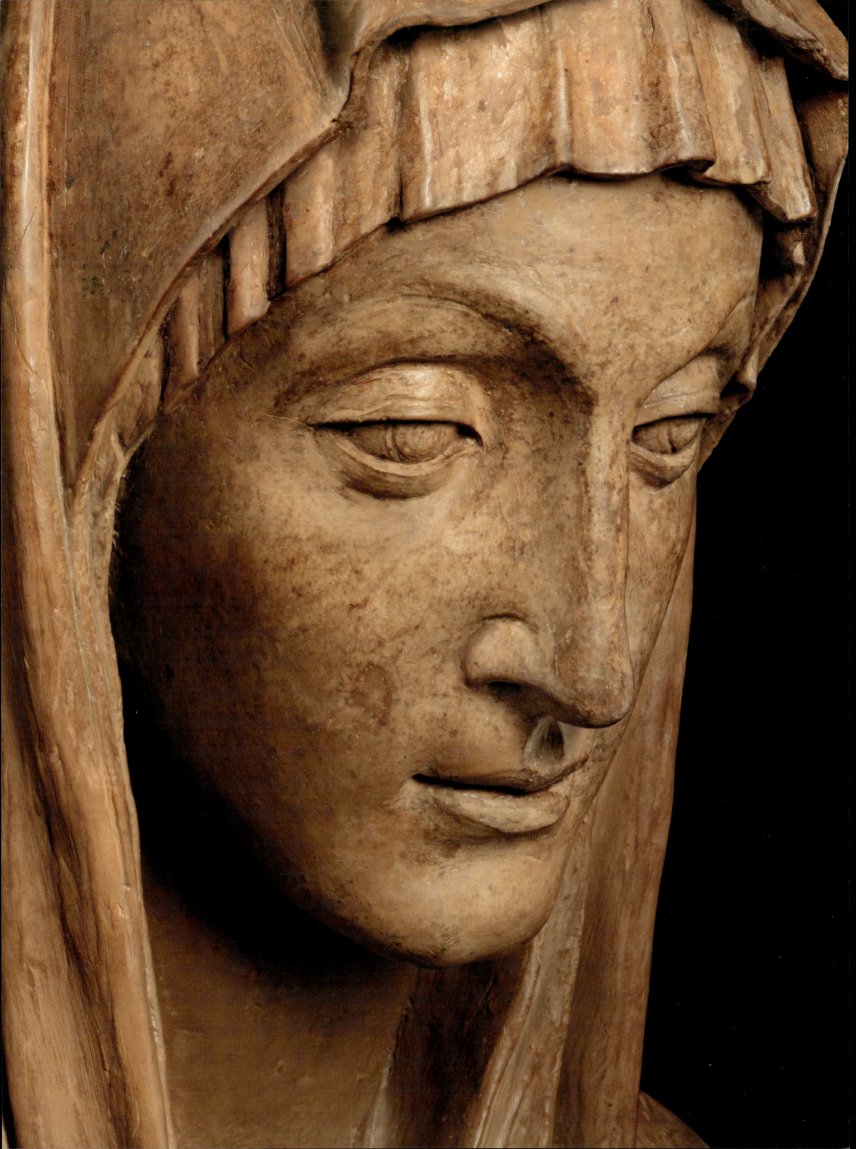

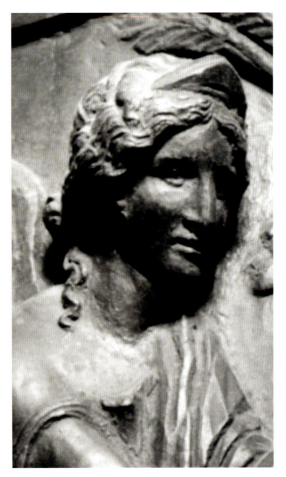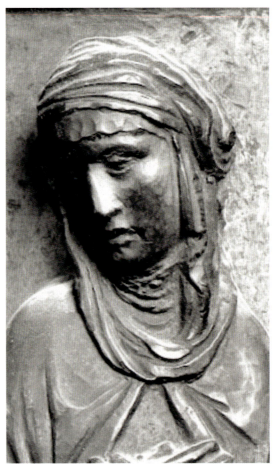

parotto 2007) and now in the Ca' d'Oro; in the head of Judith in a panel in the Choir of the Basilica of the Santo in Padua from 1505–1507 (fig. 2), and in enumerable details of the monumental paschal Candelabrum, also at the Santo, made between 1507 and 1516. There, for example, the allegory of *History* shows an identical treatment of the elements of the face, especially the sharp geometry of the nose, and the prominent forehead (fig. 3); while in the figure often identified as *Philosophy* we find a similar elongated face that is framed by a analogous regular fall of the veil (fig. 4). The Sphinxes on the base of the Candelabrum also show the same details: note the regular and impassive traits of the head, and the profound fixity of the gaze (figs. 5–6). The shape of the mouth and the form of the eyes and high smooth cheeks are virtually identical, and the somewhat more oval shape of the Madonna's face finds extremely close correspondence in the heads of the Harpies near the top of the Candelabrum (fig. 12).

Similar features also appear in Riccio's autonomous bronze statuettes, as one sees in the *Shepherd with Panpipes* in the Louvre (fig. 9). This bronze and the terracotta are especially alike in the shapes of their chins, jaws, and the areas around the corners of the mouths. Another convincing comparison is with the *Abundance* in the Bargello, particularly when both heads are viewed *en face*. (See the entry by Dimitrios Zikos in Allen 2008, pp. 303–307.)

The reliefs from the Della Torre Monument (c. 1515–1520) formerly in San Fermo in Verona, and now in the Louvre, are also highly relevant to the discussion. They present the same feminine types, whose classical faces are framed by heavy hoods, which fall in folds that

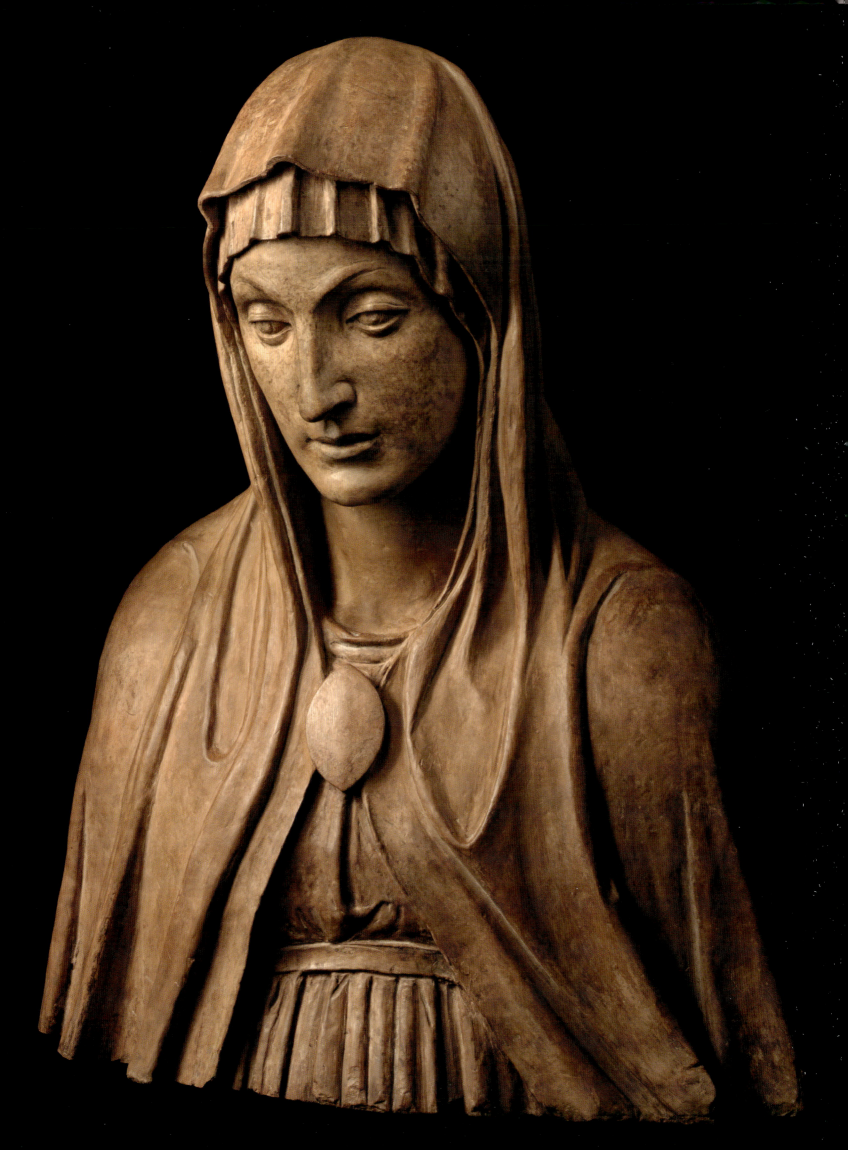

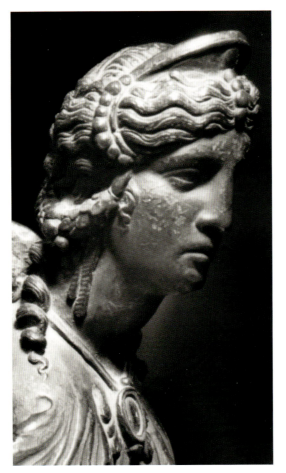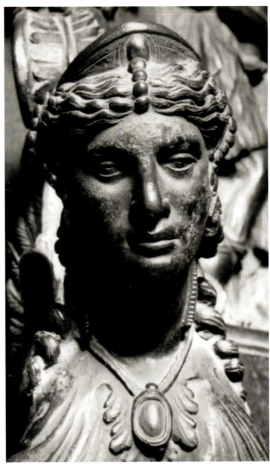

Fig. 5
Andrea Riccio,
Sphinx, detail,
Candelabrum,
Basilica del Santo,
Padua.

Fig. 6
Andrea Riccio,
Sphinx, detail,
Candelabrum,
Basilica del Santo,
Padua.

undulate vertically. Compare, for example, the allegorical figures in the *Lecturing Scholar*, and the grieving woman in the *Funeral of the Scholar* (Figs. 7–8). One should also consider the closely similar heads of the women at the left in the relief of *Paradise*. Another point of striking resemblance: the profile of the boy holding the pig in the right foreground in the *Sacrificial Scene*; his long and sharp nose, high cheekbones, slightly parted lips, and rounded chin are all like those of the Madonna.

Andrea Riccio, even early in his career, was already mentioned by Pomponio Gaurico in *De Scultura*, printed in 1504 but written in 1502, not only as a sculptor in bronze, but also as one of the most celebrated sculptors in terracotta of his time, along with Luca and Andrea Della Robbia and Guido Mazzoni. Nonetheless, his importance in the modeling of terracotta has long remained in shadow, largely overlooked both in ancient sources and in modern historiography that, not withstanding the pioneering attempts of Andrea Moschetti (1907, 1927), Leo Planiscig (1927) and Terisio Pignatti (1953), only recently has inspired dedicated studies, by Anthony Radcliffe (1983) about the mature production, and by Giancarlo Gentilini (1996; 2008) for the more elusive beginnings of his career.

The art of terracotta flourished in Padua, thanks to the magisterial presence of Donatello in the middle of the fifteenth century. Riccio was directly connected with this tradition through his early training in the workshop of Bartolomeo Bellano (a former assistant to Donatello), as is attested by contemporary sources (Gaurico 1504; Michiel 1543). Riccio may have also worked with another leading protagonist in Padua in the modeling of

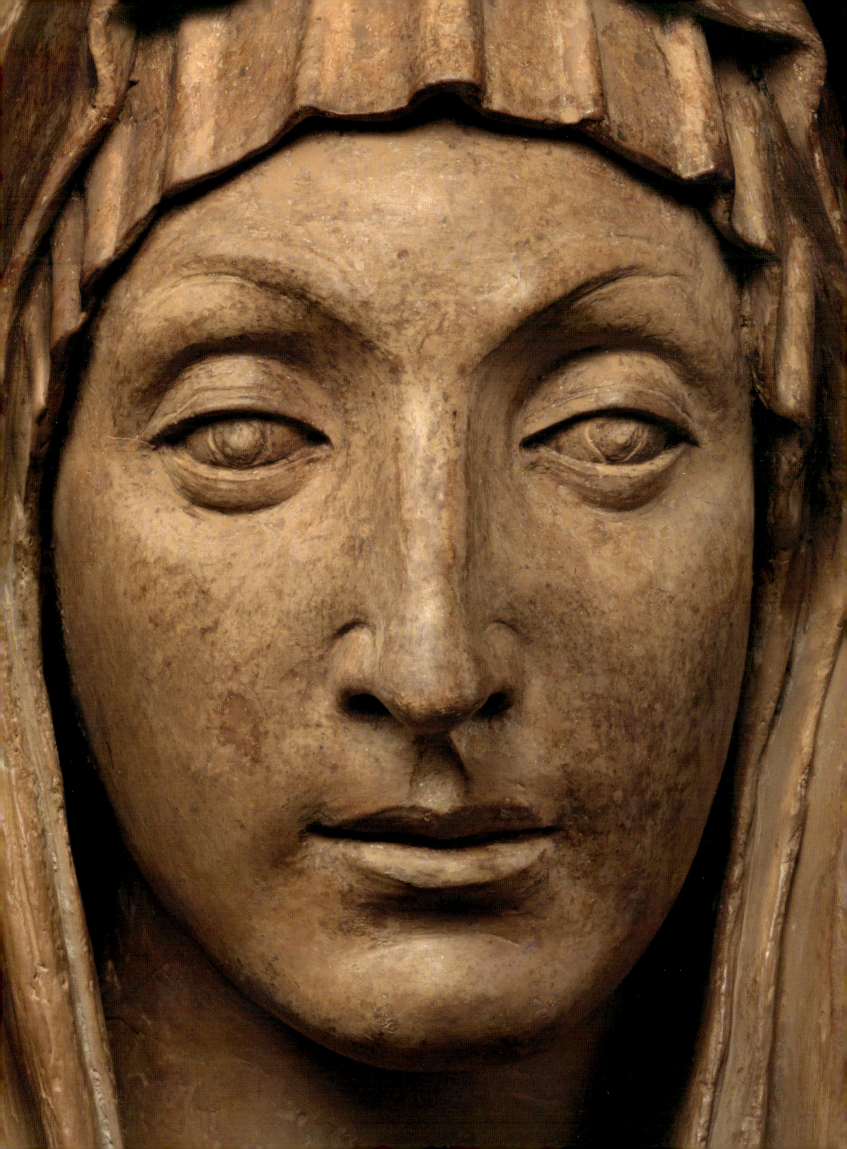

Fig. 7
Andrea Riccio,
Lecturing Scholar,
detail, Relief from
the Della Torre
Monument, Musée
du Louvre, Paris.

terracotta sculpture, Giovanni de Fondulis (Crema 1420/1430 – Padova, pre-1497), who has only recently been rediscovered (Ericani 2006), thanks to payments in 1475–1476 for the *Baptism* in Bassano del Grappa, then in San Giovanni Battista, and now in the Museo Civico. This group was formally attributed to Giovanni Minello by Cornelius von Fabriczy (1907) and Planiscig (1921) who had assigned to him a conspicuous nucleus of sculptures in terracotta. It is possible that some of these pieces can be associated with the beginnings of Riccio's career, whose early work is otherwise documented only by the Three Virtues on the bronze monument to Pietro Roccabonella in San Francesco (1496–1498). According to the contemporary diarist Marcantonio Michiel, Riccio completed this work following the death of Bellano who had begun the tomb. Among the terracotta sculptures now assigned to the youthful activity of Riccio (Gentilini 1996, 2008), it is worth recalling the *Madonna and Child* of the Bode-Museum of Berlin, which unfortunately is now in fragmentary condition (fig. 10); this sculpture can be related to the bronze monument to Paolo and Angelo de Castro in Santa Maria dei Servi in Padua (1492), perhaps made in collaboration with de Fondulis. Another early terracotta is the monumental *Madonna and Child* of the Art Institute of Chicago, datable to around 1495, which resembles the Virtues of the Roccabonella monument.

These two terracotta statues seem to provide a close precedent for the sculpture here discussed and to give further confirmation of its attribution to Riccio. In the *Madonna* of Berlin, the mantle and the veil fall in parallel folds that cover the front of the Virgin and her rapt gaze is emphasized by the powerful arching of the eyebrows—features strikingly

similar to the analogous passages of our sculpture. On the other hand, the *Madonna* of Chicago has a similar physiognomy, with a sharp nose, elongated eyelids, and prominent forehead. These same traits are also found in the *Madonna and Child* in the church of Selvazzano, not far from Padua, which only recently has been recognized to be by our sculptor (Gentilini), where the drapery, now more composed with respect to the earlier works, has the elongated recesses and flattened folds.

Fig. 8
Andrea Riccio, *Funeral of the Scholar*, detail, Relief from the Della Torre Monument, Musée du Louvre, Paris.

The highly geometric treatment of the structure of the upper part of the orbital cavity and of the superciliary arch, which one finds in our Madonna, is highly characteristic of Riccio. Besides the Madonna in Berlin, among the many other parallels in his works are the figure blowing pipes in the relief of the *Sacrificial Scene*, the bearded man to the right in the relief of *Philosophy*, and the bound Satyrs, all on the Candelabrum. Even the orbital sockets of the eyes of the Ram's-heads on the Candelabrum are structured in a like way. The shape of the Madonna's eyelids and of the muscles immediately below her eyes (the *orbicularis oculi*) is identical with what is found in many works by Riccio, for example, the Putto with the mask, the Harpies (fig. 12), and the Jupiter-Ammon heads (fig. 13), also on the Candelabrum.

The chronology of Riccio's works is not completely clear, yet the comparisons here brought forward, both with works in terracotta and those in bronze, suggest that our terracotta was made near the beginning of the sixteenth century, probably not long after his earliest period, but likely before the statues of saints in San Canziano in Padua (c.

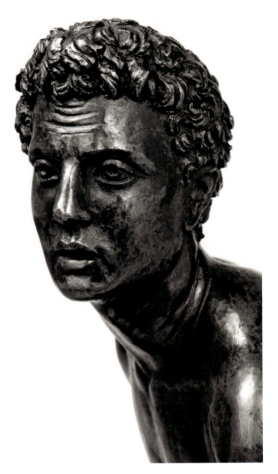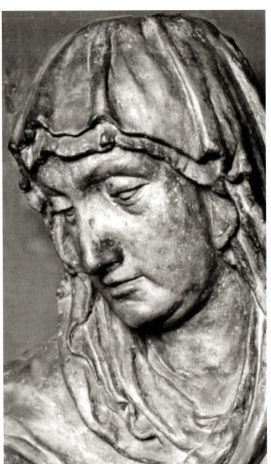

Fig. 9
Andrea Riccio,
*Shepherd with
Panpipes*, detail,
Musée du Louvre,
Paris.

Fig. 10
Andrea Riccio,
Madonna, detail,
Bode-Museum,
Berlin.

1505–1510), which are certainly by Riccio despite the reservations of Billanovich (2008). Surely, our Madonna dates before his terracottas of the *Enthroned Madonna* of the Scuola del Santo (1520), and the one formerly in the Thyssen collection, which was recently aquired by the J. Paul Getty Museum. These later works are characterized by softer and more pictorial modeling of the clay. On the other hand, the formal solutions found in our sculpture reappear in the terracotta works at the end of his career, as is demonstrated by the surviving elements of the *Lamentation* group from San Canziano of 1530. Although different in mood, the two *Maries* from this group, now in the Museo Civico Padua, have a similar severity and power in the modeling, defining the traits of the face with radical geometric purity; and while the drapery is more active, it shares a similar treatment of flattened folds and elongated recesses (fig. 11).

These works still have their original polychromy, and thus permit us to imagine the painting of our sculpture, which is now preserved only in traces of red and blue in the interstices of the folds. These terracottas also present an important point of comparison in technique. Seen from below, the central chamber of the present terracotta is cylindrical in shape, and to either lateral side are smaller cavities that ascend upward into the area corresponding to the arms. The interior structure of the *Maries* is strikingly similar to this (see Pellegrini 2008, p. 486). Moreover, in the present work as in the two *Maries*, the lower termination of the bust was made by an identical cut neatly executed in fresh clay with a metal wire. But while one believes that the statues of the *Maries* from San Canziano were the upper parts of complete figures, the absence in our sculpture of any indication of the arms shows

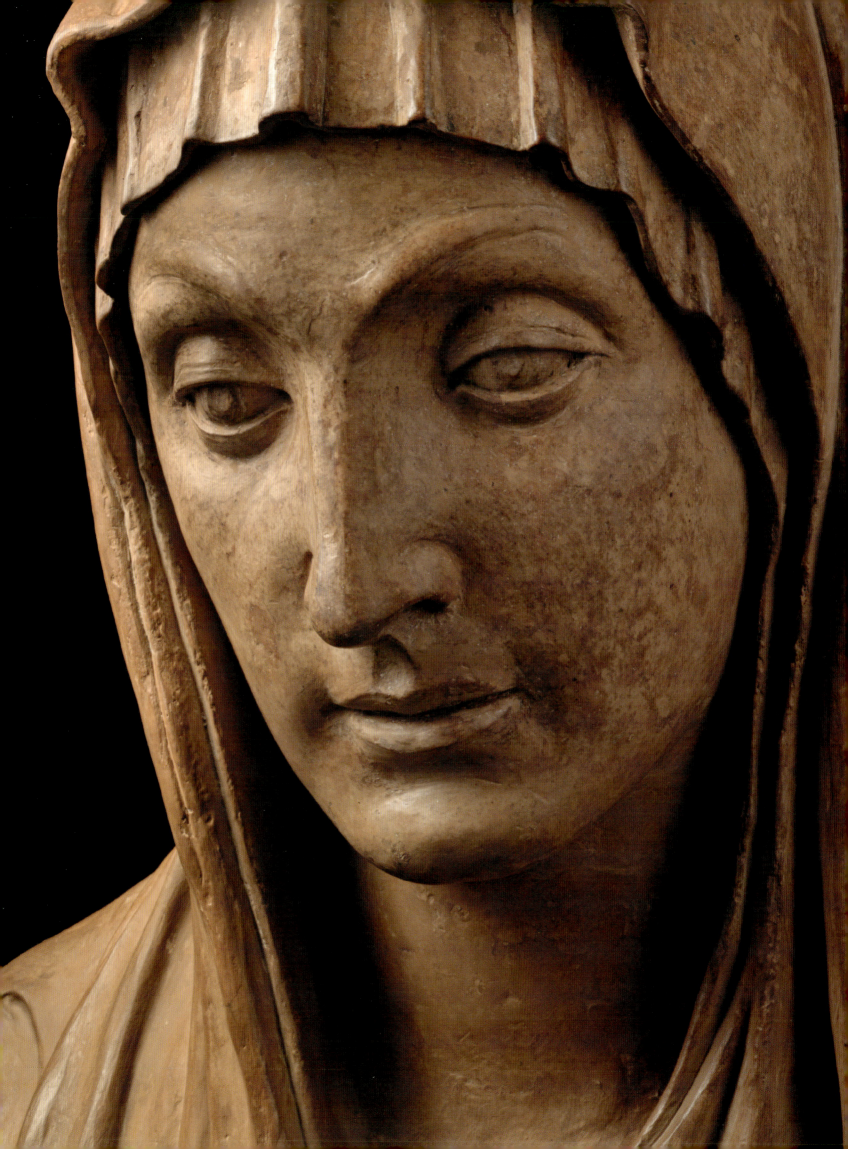

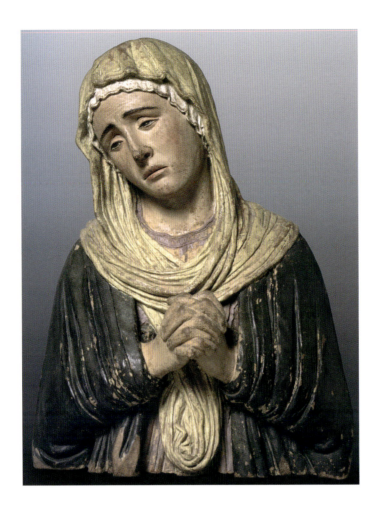

that it was intended from the outset to be a bust. To judge from the strong forward disposition of the head, and the inclination of the face downward, it was likely planned to be seen from below.

It is from such a viewpoint that the bust reveals its full emotional power. She has the abstract purity of a Greek deity at Olympia or Athens, and yet a depth of feeling and empathy beyond what is typically found in ancient art. She is an image of the solemn humanity of Mary, the mother of god.

Andrea Bacchi
Giancarlo Gentilini

BIBLIOGRAPHY

D. Allen and P. Motture, *Andrea Riccio Renaissance Master of Bronze*, New York, 2008.

A. Bacchi and L. Giacomelli, *Rinascimento e passione per l'antico. Andrea Riccio e il suo tempo*, Trent, 2008.

A. Bacchi and L. Giacomelli, "Rinascimento di terra e di fuoco. Figure all'antica e immagini devote nella scultura di Andrea Riccio", in A. Bacchi and L. Giacomelli ed., *Rinascimento e passione per l'antico. Andrea Riccio e il suo tempo*, Trent, 2008, pp. 17–57.

M.P. Billanovich, "Le quattro statue accanto all'altare maggiore di San Canziano. Andrea Riccio o una contraffazione moderna," *Bollettino del Museo Civico di Padova*, XCVII, 2008, pp. 71–86.

G. Ericani, in V. Sgarbi, ed., *La scultura al tempo di Andrea Mantegna tra classicismo e naturalismo*, Milan, 2006, pp. 92–94.

C. von Fabriczy, "Giovanni Minello. Ein Paduaner Bildner vom Ausgang des Quattrocento," in *Jahrbuch der Königlich Preussischen Kunstsammlungen*, II, 1907, pp. 52–89.

D. Gasparotto, "Andrea Riccio a Venezia: sui rilievi con le 'Storie della Vera Croce' per l'altare Donà già in Santa Maria dei Servi," in M. Ceriana, ed., *Tullio Lombardo scultore e architetto nella Venezia del Rinascimento*, Verona, 2007, pp. 389–410.

D. Gasparotto and L. Giacomelli, "L'altare Maffei in Sant'Eufemia a Verona, Giulio della Torre e Andrea Riccio," *Nuovi Studi*, XIV, 2009, pp. 115–127.

G. Gentilini, "Un busto all'antica del Riccio e alcuni appunti sulla scultura in terracotta a Padova tra Quattro e Cinquecento," *Nuovi Studi*, I, 1996, 1, pp. 29–46.

G. Gentilini, "La terracotta a Padova e Andrea Riccio 'celebre plasticatore,'" in *Rinascimento e passione per l'antico. Andrea Riccio e il suo tempo*, A. Bacchi and L. Giacomelli, Trent, 2008, pp. 59–75.

A. Moschetti, "Di alcune terrecotte ignorate di Andrea Briosco," *Bollettino del Museo Civico di Padova*, X, 1907, pp. 57–62.

A. Moschetti, "Andrea Briosco detto il Riccio. A proposito di una recente pubblicazione," *Bollettino del Museo Civico di Padova*, III, 1927, pp. 118–158.

F. Pellegrini, in *Rinascimento e passione per l'antico. Andrea Riccio e il suo tempo*, Trent, 2008, pp. 486–488, no. 109.

T. Pignatti, "Gli inizi di Andrea Riccio," *Arte Veneta*, VII, 1953, pp. 25–38.

L. Planiscig, *Venezianische Bildhauer der Renaissance*, Vienna, 1921.

L. Planiscig, *Andrea Riccio*, Vienna, 1927.

A. Radcliffe, "A forgotten masterpiece in terracotta by Riccio," *Apollo*, CXVIII, 1983, pp. 40–48.

Fig. 12
Andrea Riccio, *Candelabrum*, detail, Basilica del Santo, Padua

Fig. 13
Andrea Riccio, *Candelabrum*, detail, Basilica del Santo, Padua

PADUA
CIRCA 1515

PADUA, CIRCA 1515
SAMSON AND A PHILISTINE

Bronze, with black patina, 25.5 cm. (10 in.) high

The present statuette, hitherto known only in late and ambiguous casts, is an extremely significant addition to the study of Renaissance sculpture in Padua in the early sixteenth century. Whereas the two previously known casts have often been described as Florentine, every feature of the present work, including the details of its anatomy, the spatial planning of the group, and its black patina, typical of Venetian and Paduan bronzes, show that it was made in the orbit of Riccio and by a master of consumate importance, artistry and skill. Indeed, like the *Hecate* of Berlin, the *Shouting Woman* in the Frick Collection, and the *Europa* in Budapest, it is an early example of the exploration of narrative subject matter and acute emotion in the bronze statuette, features then still relatively uncommon.

Until today this outstanding bronze group was known in only two examples: the first, formerly in the Heseltine collection, and then the Goldschmidt-Rothschild collection, has been in Liebieghaus in Frankfurt since 1938 (Götz-Mohr, pp. 66–69); the second, coming from the Irwin Untermyer collection, is now in the Metropolitan Museum of Art (Hackenbroch, pp. LVII-LVIII). Unlike the present sculpture which no longer has its original base, those two versions have bronze bases with naturalistic detailing: a rectangular base in the Metropolitan version, an octagonal one with smoother and less highly articulated elements in the Leibieghaus cast. Moreover, in the New York version the jaw of the ass has been substituted with a club, thereby transforming the figure from Samson into Hercules.

The attribution of those two casts has been the subject of debate, which however has been notably vague and uncertain, perhaps because the two casts are certainly late: the quality

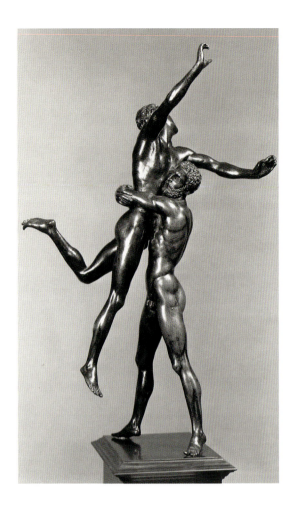

and artistic character of the original model is scarcely visible in either of these two bronzes. Writing about the Heseltine/Liebieghaus version, Bode (1908–12) described it as a Florentine work of the first half of the sixteenth century, and Götz-Mohr, Schmidt and Warren have also classified is as Cinquecento Florentine. Discussing the Untermyer bronze, Hackenbroch instead attributed it to Adrian de Vries, an idea which however was rejected by Larsson, and never again proposed, although Draper later classified the bronze as a work of a Dutch sculptor of the second half of the seventeenth century (Bode-Draper, p. 107), a position he subsequently modified, affirming only that the Metropolitan bronze is "a late cast" (see Warren, p. 52 n.)

The temptation to see the work as Florentine arises, I believe, from its subject matter, which Michelangelo famously interpreted in an enormously influential model of *Samson and a Philistine*, made around 1528. But Michelanglo's model presents a physical and spatial relation of the figures, and a canon of human form, completely different from what is seen in the present group. Furthermore, no artist among Florentine bronze sculptors of the sixteenth century—Bandinelli, Cellini, Ammannati, Tribolo, Pierino da Vinci, Danti, Giambologna—can be convincingly associated with the formal and compositional characteristics of our statuette. Compared to figure groups by Michelangelo and other Florentine Cinquecento sculptors, the pose of the two figures in the present work is notably simpler. In the present bronze, there are only two principle views, the front and the back. This contrasts sharply with the Florentine fascination with sculptures planned to be seen from multiple views. Moreover, the muscular structure of the two figures, while energetic

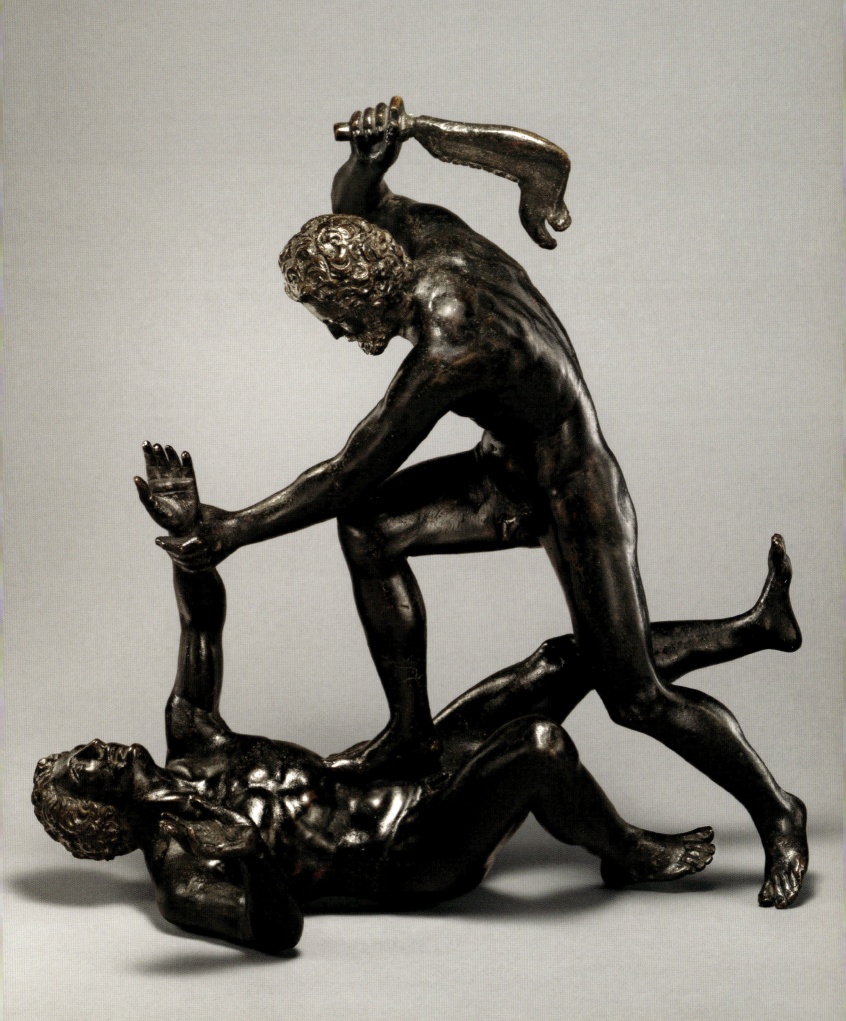

and dynamic, does not possess the heroic and monumental temperament that characterizes the sculptures of the later Cinquecento. That is because it is by an artist who did not yet measure himself against the formal world of Michelangelo; because the work was made at the beginning of the sixteenth century, not later; and because the artist was not Florentine, but active in northern Italy and specifically Padua.

Androsov in 1976 was the first to approach the correct interpretation of the style and chronology of our model, when he suggested a comparison of the Untermyer bronze with the *Hercules* in wood at the Wallace Collection, London, the only certain work by the Paduan goldsmith Francesco da Sant'Agata. The comparison is especially apt for the Samson: the two figures have in common a slender canon, and in both the muscles of the chest and back are tense with effort, and the movements of the body have a lively springiness of intensely concentrated energy. A similar impression of energy and tension expressed with exquisite elegance is transmitted by the bronze group of *Hercules and Antaeus*, in the National Gallery of Art, Washington, which also in the past has been with associated with the Hercules of the Wallace collection, and attributed to Francesco da Sant'Agata (fig. 1).

Reliable information on this Paduan goldsmith is scarce. A handful of documents confirm that he was active between 1491–1528, and the mention in *De antiquitate urbis Patavii* in 1560 of a "Herculem buxeum Francisci argentarii patavini" made in 1520, which the author Scardeone admired in the Paduan house of the antiquarian Marc Antonio Massimo, has led to the identification of the wooden statuette in London since on its base it has the inscription OPVS FRANCISCI AVRIFICIS P.[atavini] (Scardone, p. 374). Around this work of extraordinary quality, Bode (1907, 1908-12) grouped a corpus of bronzes, which included a Hercules in Oxford, the *Running Youth* in Braunschweig, and the *Hercules and Antaeus* in Washington. But the reconstruction of this great German connoisseur was called into doubt in 1963 by John Pope-Hennessy who, observing the similarity of the Oxford Hercules with the two bronze reliefs by Camelio in the Ca d'Oro transferred to the name of that Venetian sculptor the group put together by Bode. Although frequently accepted, this hypothesis has not convinced everyone; among others Hans Weilharuch, Bertrand Jestaz and Volker Krahn have expressed doubts about the stylistic cohesion of this corpus and have in some cases preferred to maintain the traditional attribution of some statutes to the Paduan goldsmith. Personally, it seems to me incontrovertible that the *Hercules and Antaeus* in Washington and the *Running Youth* in Braunschweig are by the same hand; also the recent proposal of Volker Krahn that the so called *Vasebearer* (the best example of which is in Klosterneuburg; see fig. 2) is comparable to the *Hercules* of the Wallace collection seems to me very persuasive (Krahn, pp. 212–213).

The reappearance of the present bronze in a cast of a level of quality completely absent in the two examples hitherto known permits us to make more precise the intuition of Androsov. Both Samson and the Philistine show indubitable affinities with the statuettes associated with Francesco da Sant'Agata. The pose of the Philistine is very like that of the *Running Youth* and of the Antaeus in the Washington bronze, and the shape of his face,

especially when seen in profile, also resemble the heads of these works. Furthermore, Samson's head, hair and beard resembles those of the *Vasebearer*, and his eyes—slightly bulging with sharply delineated rims—are similar to those of the *Running Youth*.

Yet other characteristics of our group, in particular the musculature of the Philistine, instead remind us more of Riccio. The vibrant and dynamic anatomy brings to mind some of the most beautiful male bodies in the work of Riccio, for example, the celebrated *Shepherd Milking a Goat* in the Bargello, and especially the *Warrior* formerly in the Beit collection (fig. 3), where the detailing of the back and of muscles over the sternum is very similar. (Interestingly, in its chasing it looks less like the Hill version of the Riccio; see Allen, pp. 252–263). Further evidence that our bronze was made by an artist in the circle of Riccio can be found in the pose of the group. It is notably comparable to that of a pair of struggling figures in the left foreground of Riccio's plaquette *Battle before a City Gate*, and it also resembles the fighting group at the right end of Camelio's relief of *Battling Nudes and Horseman* in the Ca d'Oro. Moreover, the spatial planning of the group, with just two principal views, is like that of the *Shouting Horseman* (Victoria and Albert Museum) and the *Shepherd Milking a Goat*.

While these comparisons do not show the present bronze to be by Riccio, they leave no doubt that the artist, whom we can perhaps baptize the Samson Master, had closely studied the works of the great Paduan bronze sculptor. Athough we do not know the artist's name, I believe there can be little doubt that *Samson and a Philistine* is an unrecognized

Fig. 3
Riccio, *Warrior*,
Private Collection.

masterpiece of Paduan bronze sculpture made in the years in which the sculpture of the city was dominated by Riccio.

The strong interest in expression, which one sees in the characterization of the heads of *Samson and a Philistine* also appears typical of Paduan art of the early Cinquecento. The more classic head of Samson recalls the face of the *Vasebearer* in Klosterneuburg, and the more tense and dramatic expression of the Philistine, with the mouth partly open exposing the teeth, brings to mind Riccio's character studies, such as the *Shouting Horseman* and the *Orpheus* of the Louvre. As noted above, it can also be compared with the face of Antaeus struggling to free himself from the fatal grip of Hercules in the Washington group of Francesco da Sant'Agata. It has not been observed I believe, that this interest in the representation of suffering was related to the recently discovered group of the *Laocoön* (1506). The intense pathos of the faces, especially the head of the older son, exercised a lasting impression on Venetian and Paduan sculptors, from Antonio Lombardo to Giovanni Maria Mosca, and surely also on the author of our bronze.

We know too little about Paduan bronze sculpture at the beginning of the sixteenth century to give a name to the Samson master. Only recently have scholars begun to clarify the corpus of Riccio statuettes or to reconstruct the personalities of other masters such as Severo da Ravenna or Desiderio da Firenze. Yet other major sculptors remain to be identified, and our knowledge of founders and foundries is insufficient. There are numerous statuettes of the highest quality which await definitive attribution: to mention only one

significant example: the so-called *Hecate* in Berlin, which even belonged to Marc'Antonio Michiel. The attribution swings between the usual suspects, Bellano and Riccio, but it is probably not by either of these two artists but by a master still unrecognized who could be the author of a series of masterpieces such as the so called *Shouting Woman* of the Frick Collection, the *Europa* of Budapest and the *Horseman* of the Untermyer collection, which have all been erroneously attributed to Riccio.

I believe that future studies will be able to throw more light on the genesis and author of the *Samson and Philistine*, here published for the first time. Clearly it is not a Florentine work from the middle of the Cinquecento, but instead an extremely important bronze by an artist, like Francesco da Sant'Agata or Camelio, who flourished in Padua in the era of Riccio.

Davide Gasparotto

BIBLIOGRAPHY

Denise Allen, in *Andrea Riccio. Renaissance Master of Bronze*, New York 2008, pp. 252–257, n. 25.

Sergej O. Androsov, "Tre bronzi veneziani dell'inizio del XVI secolo all'Ermitage," in *Arte Veneta*, XXX, 1976, pp. 158–163, in part. p. 161.

Wilhelm Bode, "Francesco da Sant'Agata," *Kunst und Künstler*, 5, 1907, pp. 61–62.

Wilhelm Bode, *The Italian Bronze Statuettes of the Renaissance*, London 1908-12, III, p. 12, tav. CCXXI.

Wilhelm Bode, The Italian Bronze Statuettes of the Renaissance by Wilhelm Bode, new edition edited and revised by James David Draper, New York 1980, p. 107, tav. CCXXI.

Brita von Götz-Mohr, *Liebieghaus Museum Alter Plastik. Nachantike Kleinplastike Bildwerke*, II, *Italien, Frankreich, Niederlande 1500–1800*, Melsungen 1988, pp. 66–69.

Yvonne Hackenbroch, *Bronzes and other Metalwork in the Irwin Untermyer Collection*, New York 1962, pp. LVII-LVIII, n. 32, figs. 171–172, tav. 160–161.

Bertrand Jestaz, "Travaux récents sur les bronzes I. Renaissance italienne," in *Revue de l'art*, 5, 1969, p. 80.

Volker Krahn, *Von allen Seiten Schön. Bronzen der Renaissance und des Barock*, Berlin 1995.

Lars Olof Larsson, *Adriaen de Vries. Adrianus Fries Hagiensis Batavus 1545–1626*, Vienna and Munich 1967, p. 127.

Manfred Leithe-Jasper, in *Rinascimento e passione per l'antico. Andrea Riccio e il suo tempo*, Trent, 2008, pp. 330–331, n. 43.

J. G. Mann, *Wallace Collection Catalogues*. Sculpture, London 1931, p. 101.

John Pope-Hennessy, "Italian Bronze Statuettes," in *The Burlington Magazine*, CV, 1963, p. 22 (republished in *Essays on Italian Sculpture*, London-New York 1968, p. 181).

John Pope-Hennessy, *Sculpture in the Frick Collection. Italian*, New York 1970, pp. 158–163.

Eike D. Schmidt, "Die Uberlieferung von Michelangelos Verlorenem Samson-Modell," *Mitteilungen des Kunsthistorischen Institutes in Florenz*, XL, 1996, 1–2, pp. 84, 124, fn. 32.

Jeremy Warren, *Beauty and Power. Renaissance and Baroque Bronzes from the Peter Marino Collection*, London 2010, p. 52.

Hans R. Weihrauch, *Europäische Bronzestatuetten*, Braunschweig, 1967, p. 133.

William D. Wixom. *Renaissance Bronzes from Ohio Collections*, Cleveland 1975, n. III.

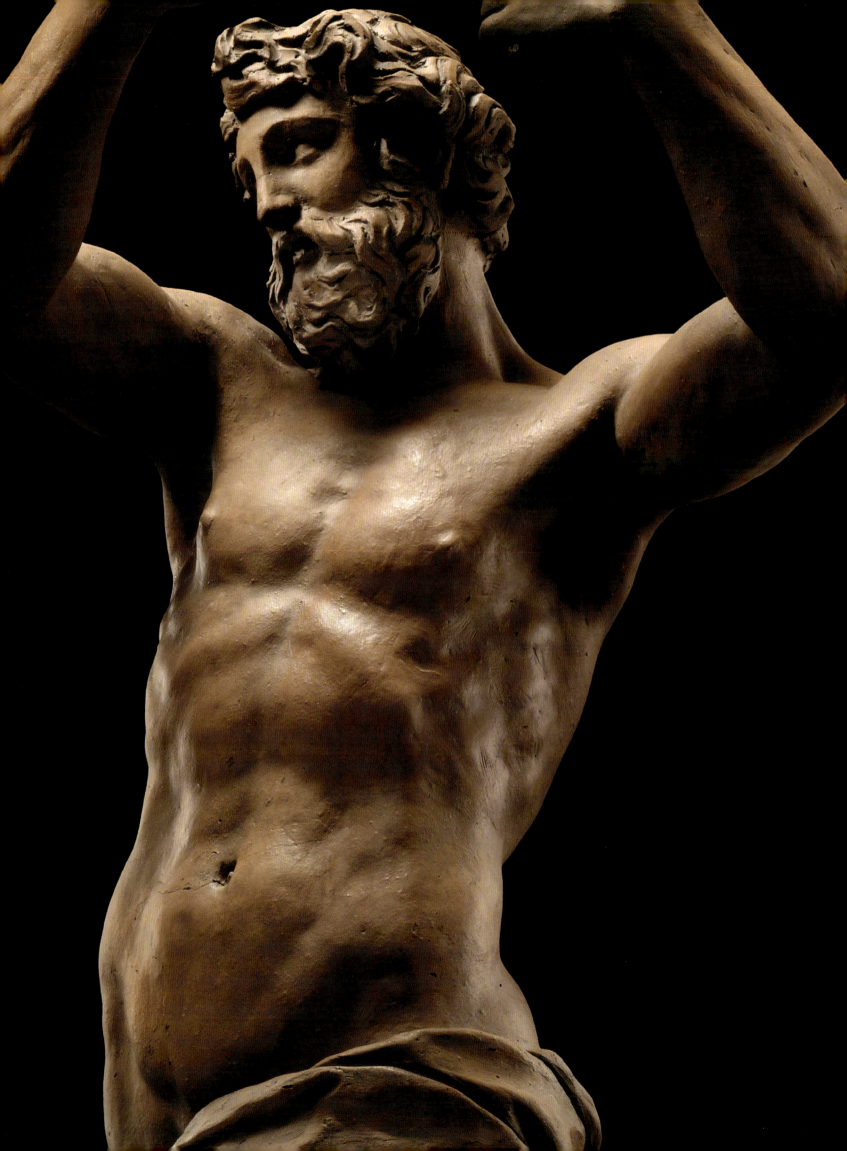

ALESSANDRO ALGARDI

ALESSANDRO ALGARDI
FOR GIAN LORENZO BERNINI
ALLEGORY

Model for a statue on Carlo Barberini's catafalque, Santa Maria in Aracoeli in Rome, August 1630. Terracotta, 63 cm. (24 ¾ in.) high

It is exceptionally rare to find a Renaissance or Baroque terracotta model as important and as well-preserved as this statue. It is all the more extraordinary when that work was commissioned by Urban VIII and involved both of the supreme sculptors of Baroque Rome, Gianlorenzo Bernini (1598–1680) and Alessandro Algardi (c. 1598–1654).

The statue is in nearly perfect condition, except for a small fill between the shoulder blades, probably due to the previous presence of a hook or rod to secure it to a wall. In all other regards, the work looks exactly as it must have immediately after being modeled by its creator's hands.

Many features of the work, especially the high degree of definition of the forms and the size of the statue, show beyond a shadow of a doubt that it is a *modello*. It was made to present the final design for the approval of both the patron, and as we shall see, the chief artist of the project for which it was made. Its design would be directly transposed and realized in the final work on the definitive scale.

Just like its function, the historical setting of this superb sculpture seems instantly certain. The style clearly points to the first third of the seventeenth century in Rome, and, in fact, recalls from the start one of the greatest sculptors of the Baroque, Alessandro Algardi. A series of considerations shows that he was the maker of this beautiful statuette and that he executed it under the direction of Bernini. Let us first consider the case for Algardi's authorship.

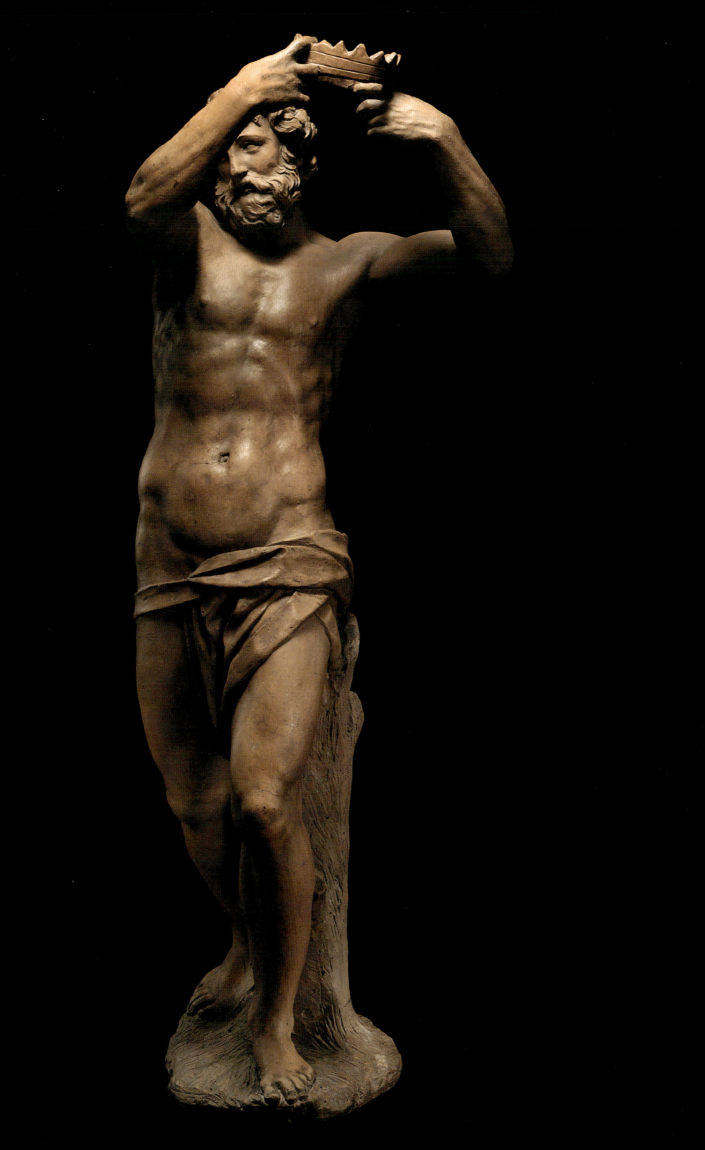

Fig. 1
Dadophore, antique
torso restored by
Algardi, Palazzo
Altemps, Rome

Fig. 2
Hercules and the
Hydra, antique statue
restored by **Algardi**,
Musei Capitolini,
Rome

The general character of the work is imbued with the noble naturalism of the Carracci.
The chiaroscuro-like vibration of the anatomy, the slight geometric simplification of the
face's traits, the thick locks of hair, and the similar placement of the arms all undoubtedly
evoke the celebrated nudes of the Farnese Gallery that served as models for successive
generations, yet were never surpassed. As Algardi was from Bologna, and was a close
student of Ludovico Carrracci, such a stylistic consonance with Annibale's masterpiece
in Rome is hardly surprising.

The work also displays the influence of the "tenderness and truth" (to cite Baldinucci's
expression) of Gianlorenzo Bernini's first monumental statues. Indeed, a closer look at
the model's profile reveals the extent to which the stance derives from Bernini's *Pluto and*
Persephone, now in the Villa Borghese. The anatomy and striding pose of the terracotta re-
call those of Bernini's marble, although void of a narrative justification as the figure does
not have to support the weight of a rebellious body but merely a light crown. Neverthe-
less, our model displays an anatomy that is not as emphatically developed as *Pluto's*. It is
smoother, more elongated, and more elegant than the Olympian forms found in the
mythological works of the young Bernini.

The terracotta eloquently reveals Algardi's style, and a series of precise comparisons with
works of the sculptor confirm that it is an autograph work by the hand of the artist. The
squareness of the face, the pose of the legs, the forms of the arms, the drapery at the waist,
and the thick hair of the figure are all like the corresponding elements of the *Saint Proclus*

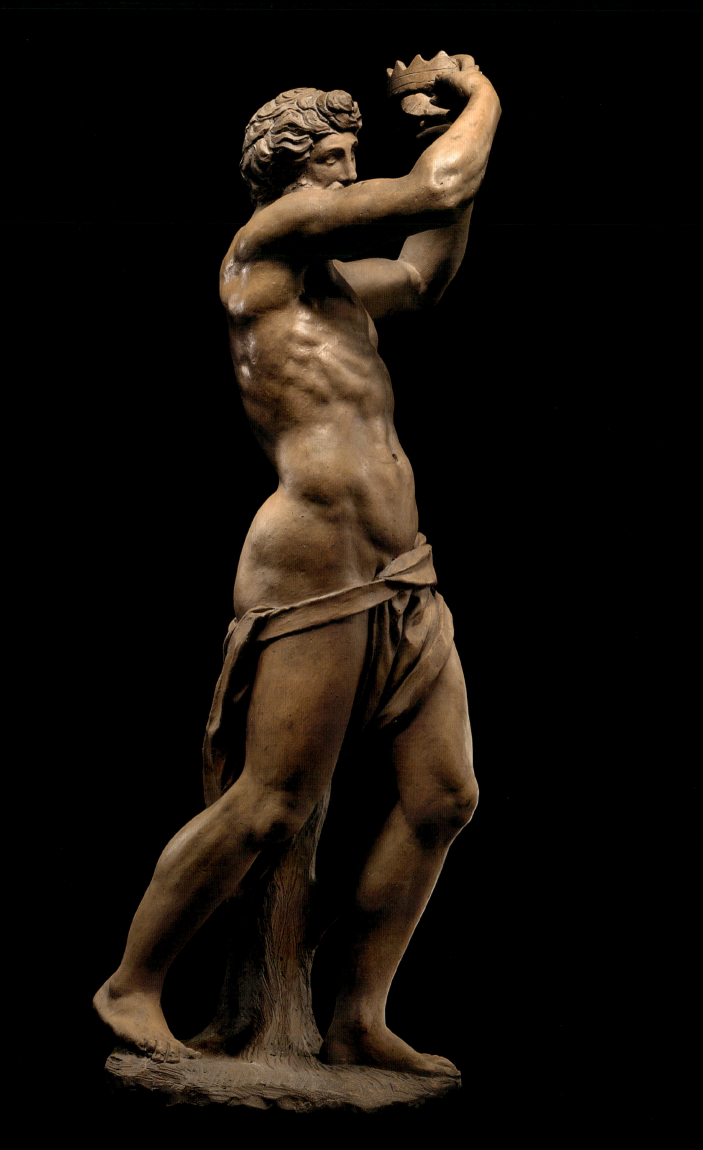

Fig. 3
Algardi, *Executioner*, model for the *Beheading of St. Paul*, terracotta, Hermitage, St. Petersburg

Fig. 4
Algardi, *The Beheading of St Paul*, marble, S. Paolo Maggiore, Bologna

model, executed by the young sculptor for Santa Maria della Vita in Bologna between 1615 and 1617. Furthermore, the general pose of the figure and the shape of the limbs recall parts of the restorations made by Algardi upon arrival in Rome on an antique torso he transformed into a *Dadophore* for cardinal Ludovisi (circa 1620); today in the Roman Palazzo Altemps (fig. 1). Another slightly later and more famous restoration—the *Hercules and Hydra* in the Capitoline Museum (circa 1630)—presents even more striking similarities with our model (fig. 2).

Numerous convincing similarities can also be observed in Algardi's figures dating from the mid-1630s, such as the model (fig. 3) in the Hermitage Museum for the *Executioner* in San Paolo Maggiore, Bologna, which shares many anatomical and compositional solutions with our model, from the raised arm to the rippling treatment of the latissimi dorsi over the rib-cage. The back of the marble statue of the executioner (fig. 4) also closely resembles that of the present terracotta, and the executioner in the relief in Bologna should be compared, too. A further likeness can be observed on the sarcophagus of Leo XI (at the Accademia of San Luca in Rome) in the figure seen from behind. Strong affinities are also evident in Algardi's works of the 1640s, including the large painted terracotta *Crucifix* in Santa Maria in Vaticano, which resembles the present statuette in the anatomy of the torso and facial characteristics.

It is also easy to find clear precedents for idiosyncratic features of the work such as the singular treatment of the hair, which looks like a halo of flames streaked by deep dark

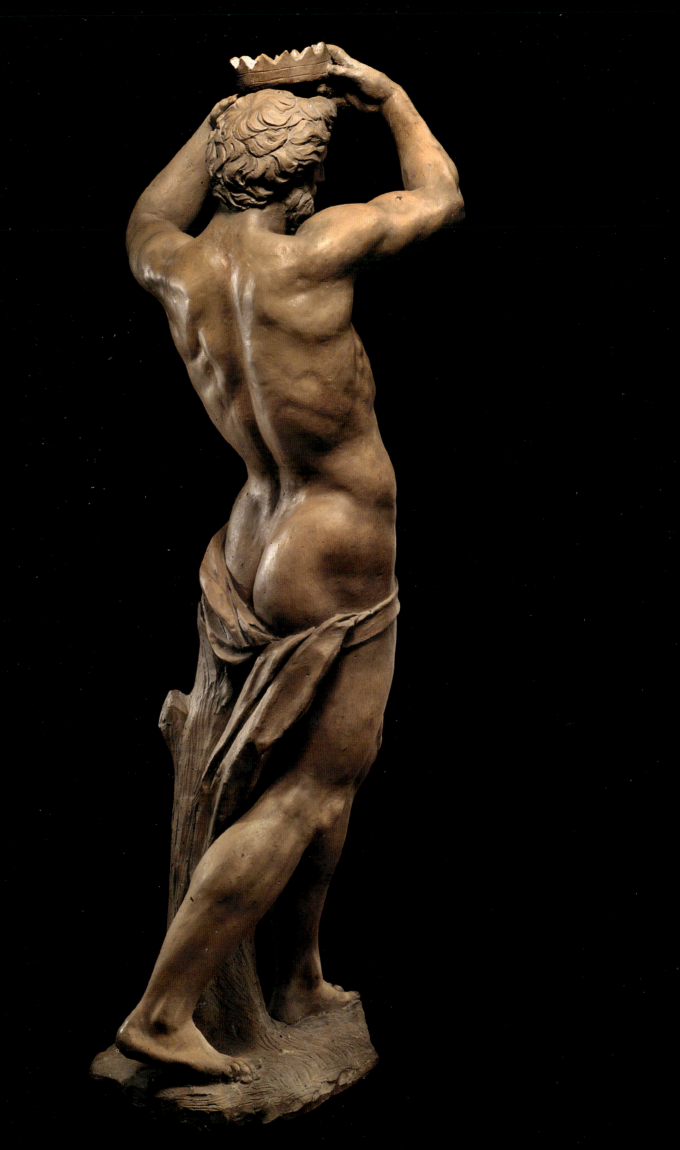

lines. This resembles the hair of the putti carrying lamps in San Domenico in Bologna, from 1619. Moreover, the noble and slightly abstract head of the model echoes those of the previously-cited *Dadophore* (notice the utterly comparable rebellious locks of hair) and of the *Saint John Evangelist* in San Silvestro al Quirinale, made in plaster between 1628 and 1629. In all three cases, the square nose, the ample arches of the eyebrows, and the chiaroscuro and wavy mass of hair appear very similar. These latter features are deeply innate to Alessandro Algardi's language; they can also be found in the much-later small bust of *Saint Matthew* in the National Gallery in Washington.

According to Giovan Pietro Bellori, the classicism of Algardi's drapery won him great praise among the cognoscenti in Rome in the 1630s. In the present work, the narrow piece of cloth set on the figure's hips like a loin cloth corresponds to Algardi's solemn draperies of that heroic period. It has the same flow as the much more grandiloquent pieces of cloth in the large terracotta group (and of its model at the Hermitage) of the *Martyrs* for the Chiesa dei Santi Luca e Martina, Rome, made around 1635 (fig. 5). More generally speaking, the saint on the left in the Roman piece seems almost like an older brother of our model. These many comparisons leave no doubt that the work is by Alessandro Algardi. They also indicate that the work was made in the first half of the 1630s, a suggestion that is further supported by examination of the work's iconography.

What does this extraordinary sculpture actually represent? The sculpture depicts a mature and bearded man—completely nude save for a piece of cloth held on his hips by a belt— who advances slowly as he raises a crown. Almost certainly he is an allegorical personification rather than a figure from history or classical or biblical mythology. His act of emphatically presenting a crown suggests that he is a representation of the love of virtue, honor or glory. In Ripa's *Iconology*, for instance, a figure that bears a resemblance is *Love of Virtue*, holding a crown of laurel. Algardi's figure is not an exact copy of Ripa's image, nor would we expect it to be in an artist of his level. Rather, it is an analogous expression of a like ideal.

It is precisely the rare iconography of a figure holding a crown that provides the decisive clue linking this model to a work mentioned in the sources. On 25 February 1630, Carlo Barberini, the dearly loved brother of pope Urban VIII and general of the papal army, died in Bologna. By March the *conservatori capitolini* (the Roman civic authorities) had already agreed to the commission of a statue of the deceased for the Sala dei Capitani in the Campidoglio, and by May they also decided to commemorate him with solemn obsequies in Santa Maria in Aracoeli.

Pope Urban VIII insisted on the involvement of Gian Lorenzo Bernini in both works, even though Bernini was extremely busy with the huge projects for the crossing of Saint Peter's. Bernini designed and directed the works in memory of Carlo Barberini, but had to leave much of the execution to assistants, including Algardi. For the statue of Carlo Barberini, Bernini restored an ancient marble torso. To the fragment Bernini added a portrait head

Fig. 5
Algardi, *Two Saints*, model for *Three Holy Martyrs*, detail, Hermitage, St. Petersburg

he carved of Carlo, and Algardi carved its arms and legs. In the tense muscle-structure of the limbs of this statue, we find such a close correspondence that our model appears to be contemporary with it.

Moreover, Bernini and Algardi also collaborated on the temporary catafalque that went into construction in May; this was destined to glow majestically with the light of three thousand torches during the funerary celebrations that took place on 3 August 1630. It was an imposing architectural structure that is known to us today through a preparatory drawing by Bernini's *atelier* preserved at Windsor Castle; the design mixes echoes from Bramante, suggestions from Michelangelo, and ideas from the Vatican Baldacchino then nearing completion. Besides the statue of death triumphing on the summit of the cupola and four "statues in military dress" (mentioned in the diary of Giacinto Gigli, see Fagiolo dell'Arco 1977, I, p. 79) which supported the urn in the centre of the temple, there were also either twelve or fourteen other sculptures in gilded clay, executed by different sculptors.

The largest group of these figures was made by Alessandro Algardi who, between May and August 1630, earned 132 crowns for four statues. As Jennifer Montagu noted, we do not know what the subjects of these works were nor how much liberty Bernini gave to his collaborators (Montagu, 1985, p. 421). However, thanks to the Windsor drawing, we know that it must have dealt with allegorical figures that celebrated the virtues of the defunct. Particularly, in the lower register, we notice on the right two male semi-nude figures with outstretched arms presenting objects that are clearly attributes or symbols.

One cannot but notice how our model appears to belong to the same series. Both its iconography of an allegory of a moral quality or a disposition of the soul such as *Love of Virtue*, as well as its typology of a male figure with outstretched hands offering or showing an object point to this conclusion. Indeed, if we insert the figure beside the other statues in the Windsor sketch, it is striking how well it accords with the other statues in the group. Of course, it is important to remember that the drawing we have does not show the final design. Some contracts for the project record the desire to display the statues differently, and we do not know its final arrangement (Bilancia, 2004, pp. 95-117). Yet the convergence of the clues is so impressive that it leads us to conclude that our model was made by Algardi for one of the statues of Carlo Barberini's catafalque.

This would perfectly explain the unusual iconography of the sculpture. Furthermore, the statue clearly was designed to be seen from below; a vantage point set beneath the model increases the figure's dynamism while also permitting a better view of his face. This would mean the work was made for the approval of Gian Lorenzo Bernini who, as author of the project and head of the site, bore the ultimate responsibility for the enterprise.

The date of 1630, and the participation of Bernini, even if limited to supervision, or the preparation of some rapid sketches, would make perfect sense with both the stylistic features of the piece which had already lead us to place it around this time, and the quotation from a recent work of Bernini, *Pluto and Proserpina*. (A direct quote from Bernini is very unusual in Algardi's work.) We should also note that Bernini's masterpiece was at that time kept at the Villa Ludovisi where Algardi had worked as a restorer and sculptor during the second half of the 1620s.

The original function of the statue can only be an hypothesis for now, even if an unusually well-founded one. Nonetheless, there can be no doubt that this superb sculpture is by Alessandro Algardi. An important work from the glorious era of Baroque Rome has come to light once again.

Tomaso Montanari

BIBLOGRAPHY

F. Bilancia, "Le esequie di Carlo Barberini nella chiesa di Santa Maria in Aracoeli," in *Studi sul Barocco romano. Scritti in onore di Maurizio Fagiolo dell'Arco*, Milan, 2004, pp. 95-117.

J. Montagu, *Alessandro Algardi*, New Haven and London, 1985, p. 421.

J. Montagu, ed., *Algardi, L'altra faccia del barocco*, Rome, 1999.

M. Fagiolo dell'Arco, S. Carandini, *L'effimero barocco*, Rome, 1977, vol. I, p. 79.

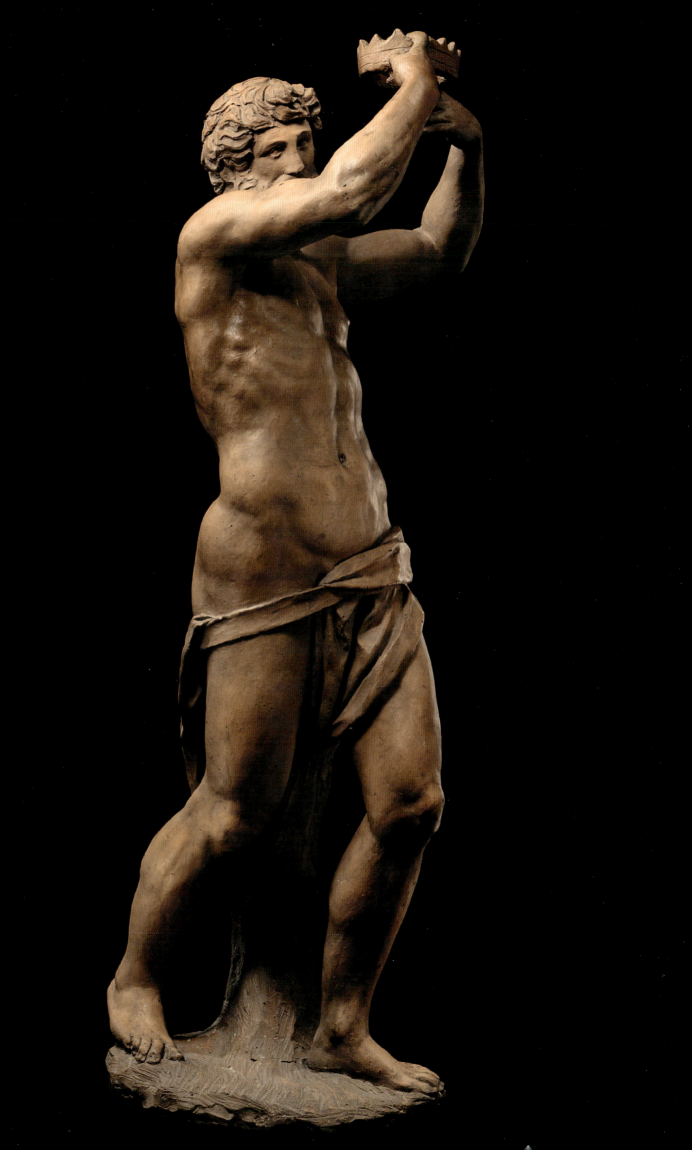

DOMENICO PIERATTI

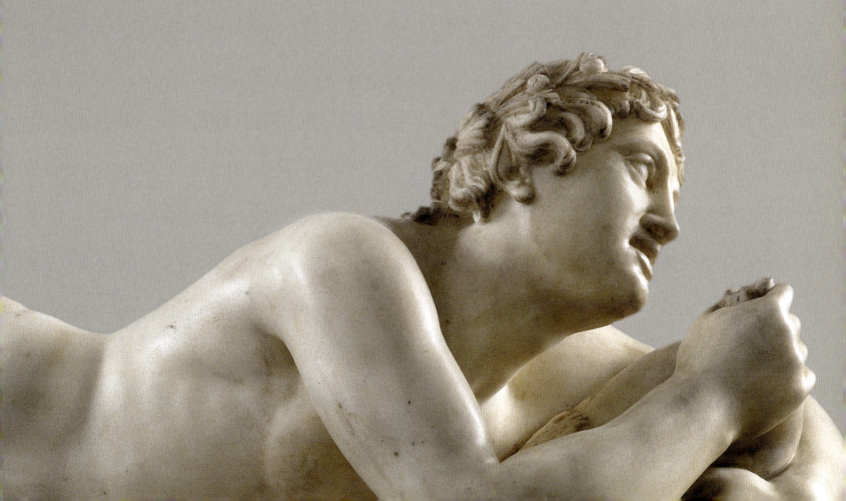

DOMENICO PIERATTI
SATYR LYING ON A PANTHER SKIN

Carrara marble, 90 x 33 x 27 cm. (35 ¹/₂ x 13 x 10 ³/₄ in.), circa 1640–50

The present sculpture represents an inebriated youth, reclining on a panther's skin strewn upon a lawn, as he pulls a full wineskin to his lips to drink. His goat-like tail and ears, and his crown of pinecones and needles, reveal that he is a satyr. Beardless and fresh-faced, the sculpture simultaneously recalls the youthful god Bacchus, while the figure's provocative pose is based on a celebrated Hellenistic sculpture of a hermaphrodite, now in the Louvre (fig. 1). Our sculpture is the most important seventeenth-century marble statue inspired by this source that has ever been discovered.

The Hellenistic sculpture was immensely famous in Baroque Rome. In July 1619, Cardinal Francesco Maria del Monte remarked that "a beautiful statue of a woman awaking as a man" had recently been found in the garden of the Carmelite Fathers of Santa Maria della Vittoria in Rome. Though in a damaged state, the piece was remarkable enough to be coveted—and immediately obtained—by Cardinal Scipione Borghese, who in turn entrusted the restoration of the work to his favored sculptor, the young Gian Lorenzo Bernini. By February 1620 the *Hermaphrodite* had been restored and positioned atop a marble mattress carved by Bernini. It was then installed in the center of the largest room on the ground floor of Villa Borghese, lending an erotic charge to the surrounding space that would come to be augmented in the following years by Bernini's famous works, the *Rape of Proserpine* and *Apollo and Daphne*.

The restored hermaphrodite exemplified the subtle dialogue between antiquity and modernity that so deeply engaged Baroque artists and patrons. Moreover, it elicited the

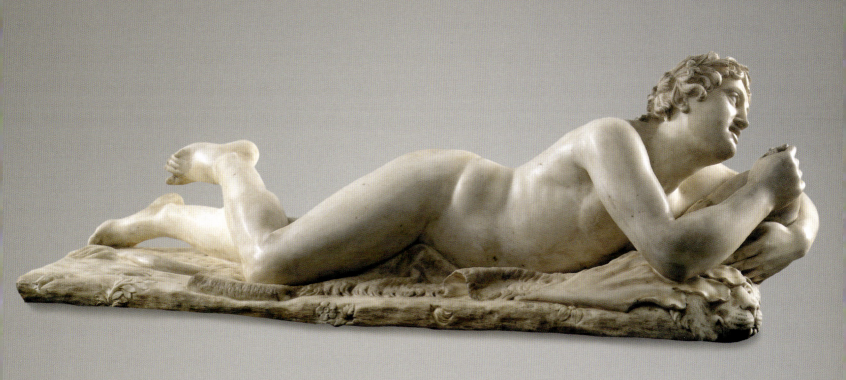

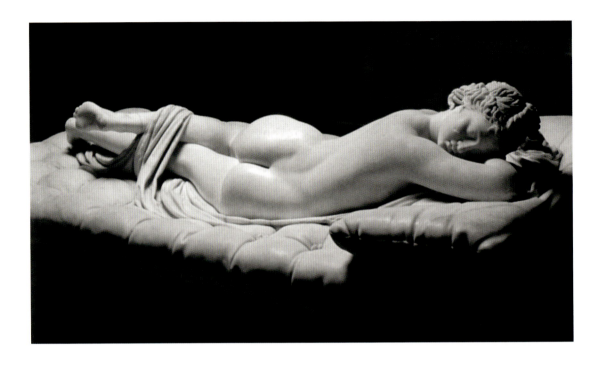

Fig. 1
Hermaphrodite,
Musée du Louvre,
Paris

keen interest of Florentine artists by appealing to their taste for languid refinement. The Florentine sculptor Giovanni Francesco Susini (1585–1653) was among those who took note. In 1639 he produced a superb Baroque interpretation of this sculpture in an excellently cast and chased bronze statuette, now in the Metropolitan Museum of Art.

This episode was likely a decisive factor in the genesis of our marble, as it appears to stem from an analogous stylistic temperament and a similarly unusual iconographic and compositional challenge. While the soft, deeply-delineated limbs of the *Satyr* evoke the style of the Florentine baroque painter Francesco Furini (c. 1600–1646), the calligraphic treatment of the panther skin, with its paw covering the slain beast's muzzle, lends the marble a sinuous elegance that recalls the work of the contemporary engraver Stefano Della Bella (1610–1664).

Though it is unsigned, the marble sculpture was clearly created by an artist capable of building upon what Susini had introduced to Florence. The piece audaciously surpasses both the ancient prototype and its modern variant by suspending the satyr's right foot not in bronze, but in marble, and without the aid of a supporting drapery brace. This virtuoso achievement of marble carving strongly indicates that it is by Domenico Pieratti (1600–1656), considered the "prime exponent of his profession in this city," as a contemporary document describes him. The smooth, somewhat surprised countenance of the *Satyr*—with all its features shallow-cut, from the wide-open and thick-lidded eyes to the gaping mouth—is a hallmark of the sculptor's *oeuvre*. This trait is found throughout his

work, from his beginnings in the crude, almost neo-renaissance *John the Baptist* now in the Bargello or the *Slave* in the Casa Buonarroti, to the much later *Unconditional Love Opening a Heart with a Key* in the Boboli gardens, and a second, admirable version of *John the Baptist*, now in The Metropolitan Museum of Art (fig. 2),

The latter, a very accomplished work, is virtually a seated version of the *Satyr*, conceived with the same smooth, rounded limbs, and with undercutting similarly reminiscent of Pieratti's softened approach to Michelangelo's later works. The figure's head is crowned by well-wrought fronds of hair formed by the same florid, dangling locks shared by the *Satyr*. This foliage-like treatment reappears, more contrasted and pronounced, in the Angels, dated to 1644, that support each of the two the baptismal fonts in the Florentine church of Santi Michele e Gaetano. Although iconographically divergent, the two caryatid figures share these and other stylistic affinities with our recumbent *Satyr*. In fact the sculpture's most obviously tactile feature, the juxtaposition of smooth, svelte limbs with the uncannily-rendered bristly texture of fleece, appears to be a constant in the artist's work. The camel skin in the earlier *St. John* is echoed in the lamb's fleece of the Metropolitan Museum version, returning, softer and more sensuous, in the lining of the royal mantle of the Pitti Palace *Zeal*. The texture reappears yet again, coarser and more imposingly, in the lion figure of the large *Jole* group at Palazzo Galli Tassi, where it contrasts with the shiny calves of the intertwined legs, producing the same decorative counterpoint that grazes the body of the Satyr.

Prof. Claudio Pizzorusso's scholarship has clarified the extent to which Domenico Pieratti was receptive to the classical tradition at a time when Florentine sculpture was otherwise still dominated by the powerful mannerist imprint of Giambologna (1529–1608). A strong antiquarian temperament permeates the *Satyr*. Indeed, our sculpture represents the apex of classicism in the works of Domenico rediscovered thus far. The rendering of the hermaphrodite composition eschews the modern stylistic traits inspired by Bernini, and likewise does not partake in the native Florentine decorative idiom derived from the theatrical influence of Bernardo Buontalenti (1536–1608) and rekindled by Susini. Instead the work displays the sculptor's ability to translate and paraphrase the Borghese Hermaphrodite into a synthesis of *all'antica* elements (evident, for example, in the handling of the figure's hair).

This act of sculptural exegesis is highlighted by an understanding of just how closely linked the *Satyr* is with the Roman classicism typical of the final years of Urban VIII's pontificate (1623–1644). The sensuality of a gleaming body lying on a vibrant animal skin seems directly lifted from the fantasy of Nicolas Poussin's contemporaneous *bacchic* canvases. Pizzorusso has already raised the possibility of the French artist's influence on Pieratti's stylistic development, and a comparison with the reclining figure of Venus in Poussin's *Midas and Bacchus* (Alte Pinakotek, Munich) aptly demonstrates how essential this painter's interpretation of Titian and Correggio was to the *Satyr's* sculpted form. Moreover, the geometric simplification of facial features in Pieratti's work also demonstrates his receptivity to the *all'antica* works of the Roman sculptor Alessandro Algardi (1598–1654), a great rival of Bernini.

Yet in addition to drawing from these modern sources, the *Satyr* combines the model of the Borghese hermaphrodite with other well-known recumbent figures from antiquity, displaying an almost archaeological familiarity with ancient statuary. Though Pieratti's naturalistic plinth that substitutes for Bernini's mattress is likely based on the example shown in an early graphic reproduction of the work, which by 1638 had been replicated in François Perrier's successful collection of prints, the conceit of using a panther-skin to smooth out and unify the figure's intersection with the base is indebted to another famous Roman Hermaphrodite, now housed in the Uffizi. This figure, reclining on a lawn and an animal skin—probably added by Ippolito Buzio (1562–1634)—was housed in the Ludovisi collection during Pieratti's lifetime, prior to being purchased by the Medici. Another famous sculpture in the Ludovisi collection inspired Pieratti to transform the reclining figure's pillow into a soft, bulging wineskin; the *Drunken Silenus* group, celebrated in Ulisse Aldrovandi's guide to Rome and enthusiastically copied by engravers from Giovan Battista Cavalieri to Joachim Von Sandrart, remains close to its original location in the courtyard of the American Embassy in Rome. Lastly, the ambiguous iconographical status of Pieratti's *Satyr* and the closeness of the figure's body to the panther skin may have been suggested by a work destined to become famous; the *Barberini* Faun, now in Munich, was at the time probably not a seated figure, as it is now, but a recumbent one. It was often referred to as a *Bacchus* during the years in which Pieratti frequented its owner's palazzo.

It may be surprising that a mid-seventeenth-century Florentine sculptor elected to use this commission as an opportunity to translate a broadly-based knowledge of antiquity into a modern idiom. Yet in doing so he was able to produce a successful synthesis of sources from both the Bacchic and Hermaphroditic traditions, as were visible in the most *au courant* collections of papal Rome. Fundamentally, Domenico Pieratti was the most Roman of the Tuscan Granducal sculptors, besides being a knowledgeable restorer of antiquity, as demonstrated, for example, by the *Lilting Satyr* in the Uffizi, whose head provides yet another means for confirming his authorship of our marble.

Nothing is known of the circumstances or patronage that saw the birth of our reclining satyr, which can nonetheless be situated persuasively within Pieratti's production of the 1640s. Its creation likely followed an encounter with Susini's bronze after 1639 and came at a time when Pieratti had considerable ties to Rome, perhaps even travelling there himself. It is possible to imagine a patron among the circle of the Barberini family (which had previously commissioned Pieratti's *Latona*) or of Cassiano dal Pozzo (who, although only knowing it through a drawing, considered the Galli Tassi sculptural group "very beautiful"). Though the subject matter of the piece might appear inappropriate for a high-ranking patron, the Roman cultural elite of the period tolerated a high degree of eroticism in the representation of male figures, as exemplified by Caravaggio's *Amor Victorious* of 1602–1603. This rarified clientele would have been capable of appreciating such a coy, but also cleverly ambiguous, translation of an ancient iconography into the late, languid style of seventeenth-century Florentine art.

Tomaso Montanari

BIBLIOGRAPHY

Giuliana Guidi and Daniela Marcucci, ed., *Il seicento fiorentino: Arte a Firenza da Ferdinando I a Cosimo III*, exhibition catalogue, Florence, 1986–7.

Francis Haskell and Nicholas Penny, *Taste and the Antique - The Lure of Classical Sculpture 1500–1900*, New Haven and London, 1981, pp. 234–236.

Claudio Pizzorusso, *A Boboli e Altrove. Sculture e Scultori Fiorentini del Siecento*, Florence, 1989.

Giovanni Pratesi, *Repertorio della Sculture Fiorentina del Seicento e Settecento*, Turin, 1993, pp. 56–7, pls. 446–467.

GIOVAN
BATTISTA
FOGGINI

GIOVAN BATTISTA FOGGINI
HERCULES AND THE CENTAUR

Stucco, with traces of polychrome and gilding, 44.5 cm. (17 ¹/₂ in.) high, circa 1687–1690

This rare statuette in stucco by Giovan Battista Foggini (1652–1725) was inspired by the well-known marble by Giambologna that was made between 1594 and 1600 for Ferdinando I de'Medici, today under the Loggia dei Lanzi (fig. 1). The present work is probably derived more directly from the model of the same subject that Giambologna made in 1576 on commission of the Grand Duke Francesco I as part of a series of the Labors of Hercules that was cast in silver for the Tribuna of the Uffizi.

This series, a masterpiece of small-scale Tuscan sculpture, was immediately famous, and the most influential composition of the group was that on which the present stucco is based. Giambologna's prototype has never been discovered, unless perhaps it can be identified in the two fragments in wax and the bozzetto in terracotta in the British Museum. However, the composition reappears in numerous versions. An extremely early reproduction is found on the back of a metal cast in 1588 by Michele Mazzafiri for Ferdinando I. Some years later the same composition was represented, together with other Labors, in the original bronze and in a version in sugar for the royal banquette in the Sala dei Cinquecento in the Palazzo Vecchio in 1600 for the wedding of Maria de' Medici to Henry IV of France.

At this time Giambologna's silver group was transferred from the Tribuna of the Uffizi and placed atop the phantasmagorical credenza in the form of the fleur-de-lys designed by Jacopo Ligozzi (Spinelli 2005, p. 132). Also, between July and September 1600, the models for the versions that had been executed in sugar were covered in silver and gold under the

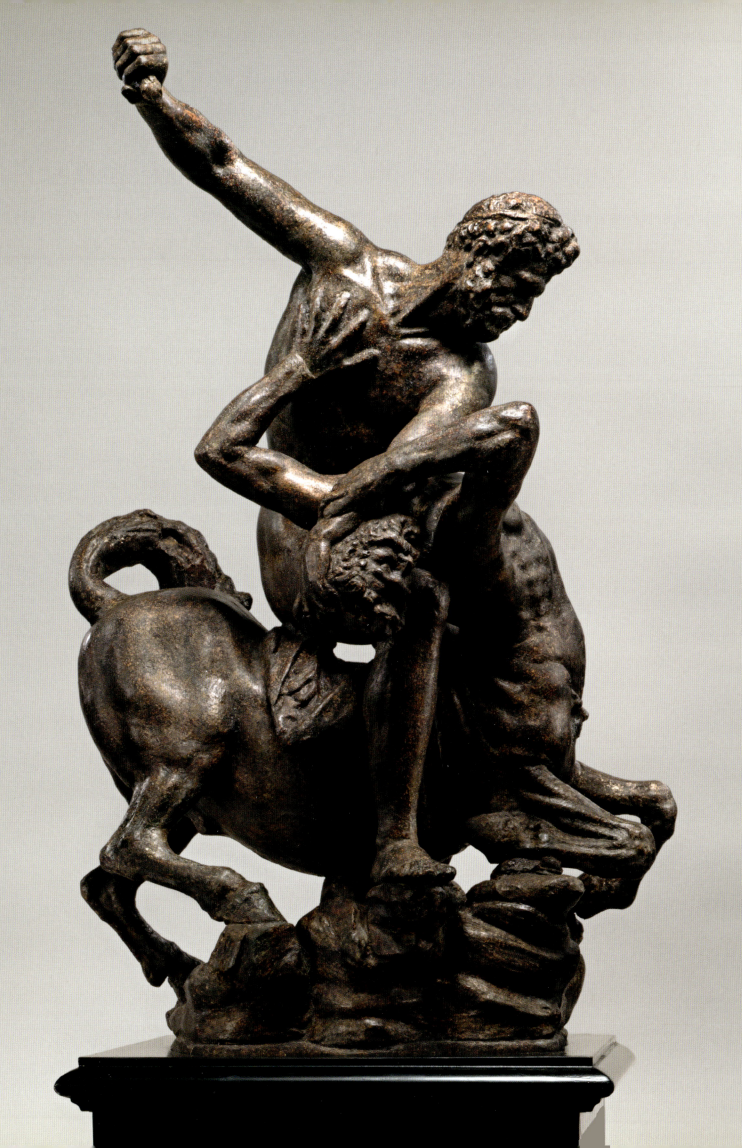

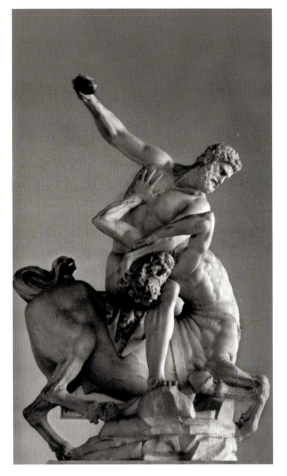

Fig. 1
Giambologna,
Hercules and the
Centaur, Loggia dei
Lanzi, Florence

Fig. 2
Giovan Battista
Foggini, *Sant' Andrea*
Corsini intervening at
the Battle of Anghiari,
Cappela Corsini,
Santa Marino del
Carmine, Florence

supervision of Giambologna himself in his studio in the Borgo Pinti, and finished by his pupil Pietro Tacca, Francesco and Gaspare della Bella, and other artists. These went to decorate the tables of the Queen and her guests that were laid out along the length of the Sala (Spinelli 2005, pp. 134–135).

In the course of the following century the Giambologna prototype of *Hercules and the Centaur* appears frequently, above all in the work of sculptors who had direct knowledge of the sixteenth century master's models, and who produced examples of very high quality. Among the most significant examples are works by Antonio Susini in the Galleria Colonna in Rome, from the Salviati collection, that is documented in 1609, and another work in the National Archeological Museum of Madrid (Coppel, 2009, p. 132, no. 15). Another is the work catalogued as "Italian, Florence, eighteenth century after a model by Giambologna", of notably high quality, sold at Sotheby's London in July 2008 (lot 122.) The beautiful version in bronze in the Kunsthistorisches Museum in Vienna (Radcliffe–Liethe-Jaspar, in *Giambologna* 1978, pp. 128–129, n. 81) and the versions documented as by Pietro Tacca, made by the artist during the brief period from 1612 to 1634 (Zikos 2006, p. 175), are other examples.

At the end of the seventeenth century Giovan Battista Foggini made several casts of this model. As "Scultor de corte" from 1687 he occupied the studio in Borgo Pinti that had once been Giambologna's. As we know from a recently discovered document, during this period the studio contained at least ten *modelli* by Giambologna for the Labors of Hercules

Fig. 3
Giovan Battista Foggini, *Battle of the Lapiths and Centuars*, Museo di Doccia, Sesto Fiorentino

series, including "Hercules Killing a Centaur" and "Hercules and a Centaur." These were two-thirds of a braccio high, about the same scale as the present stucco, excluding its rockery base.

In the late seventeenth century, Foggini kept alive the memory of the great works of Florentine bronze sculpture of the late sixteenth century by offering new versions, sometimes with variations on the original. These works were created for the greatest collections of the day, not only in Florence, but throughout Europe. Foggini also used Giambologna's famous prototype as the point of departure for original interpretations of the *Hercules and the Centaur*, an example of which is found, in addition to this stucco model, in the magnificent bronze version formerly in the Piasecka Johnson Collection and recently sold at Sotheby's London.

The correspondence between that sculpture and the present modello is based on the dimensions (44.2 cm for the former; 44.5 cm for the latter), the dramatic tension of the two figures engaged in a battle to the death, in the morphology of the rocky base on which they stand (more fully developed in the bronze), and the modeling of the details. The level of detailing appears more summary in the stucco, owing to the nature of the material used, whereas in the bronze it is more scrupulously developed. There we see the artist calling to his service all his significant ability in finishing, chasing and patination; in the present work instead the emphasis is on the dynamic power of the composition.

This is a work of the early maturity of Foggini, who, as a young and rising artist was trained in Rome at the Academy established by Grand Duke Cosimo III de'Medici. The stucco model *Hercules and the Centaur* attests to Foggini's interest in statuettes, an interest that was partly due to a physical disability resulting from illness that limited his activity in monumental sculpture (recorded by Baldinucci ed. 1975, pp. 386–387, but already clearly evident during his student years in Rome; Lankheit 1962, pp. 246–253). It would ultimately develop in his later career into a mastery of relief, groups of two or more figures, and in the naturalistic works produced under his direction by the ducal workshops.

Foggini used stucco, a medium that is supple, versatile and inexpensive, to great effect. The present work, modeled expertly and then enriched with a patina that may have then been gilded (traces of gilding can be seen on the surface of the stucco) can be related both to his work in late-Medicean Florence as well as a recently published youthful work, a lovely relief of the "Sacra famiglia", datable to between 1676 and 1678 and modeled immediately upon his return to Rome (R. Spinelli, in *Una gloria europea* 2010, pp. 158–159, cat. 39). His extremely successful exploitation of this material is further seen in his many works as a designer of decorative programs for architectural interiors such as the Galleria and Biblioteca of the Palazzo Medici-Riccardiana (Spinelli 2003).

The subject of the violent struggle between two figures, and in this case specifically between man and centaur, is common in Foggini's early work. He treated the subject in drawing, in relief, in bronze and in porcelain. It appears in a group of youthful drawings in the drawings collection of the Farnesina in Rome (L. Monaci, in *Disegni* 1977, pp. 23–29 nn. 1, 4–5; Monaci 1977, pp. 26–31.), in the wax relief in the Museo della Manifattura Ginori di Doccia in Sesto Fiorentino (Lankheit 1982, fig. 59; p. 131), in a now-lost bronze panel (Lankheit 1962, p. 237. Doc. 48) and finally in the middle of the seventeenth century in the white porcelain, perhaps executed by Gasparo Bruschi, known from a beautiful fragment of the left side in the Victoria and Albert Museum (Lankheit 1982, fig. 60.)

Foggini's fascination with the pose of Hercules is especially clear. His variations include the warrior on horseback at the extreme right of *Sant'Andrea Corsini intervenes in the Battle of Anghiari* (fig. 2) and especially the man at the far right foreground of the *Battle of the Lapiths and Centaurs* (fig. 3).

Riccardo Spinelli

BIBLIOGRAPHY

F. S. Baldinucci, *Vite di artisti dei secoli XVII–XVIII* (1725-1730 ca.), Florence, Biblioteca Nazionale Centrale, Fondo Palatino, ms. 565, prima edizione integrale a cura di A. Matteoli, Roma 1975, pp. 373-390.

K. Lankheit, *Florentinische Barockplastik. Die Kunst am Hofe der letzten Medici 1670–1743*, Munich, 1962, pp. 47-109.

Gli ultimi Medici. Il tardo barocco a Firenze 1670–1743, exhibition catalog (Detroit-Florence), Florence , 1974.

Kunst des Barock in der Toskana. Studien zur Kunst unter den letzten Medici, Munich, 1976.

L. Monaci, "Alcuni disegni giovanili di Giovan Battista Foggini", in *Kunst des Barock in der Toskana*, 1977 pp. 24-32.

Disegni di Giovan Battista Foggini (1652–1725), exhibition catalog curated by L. Monaci, Florence, 1977.

Giambologna 1529–1608 Sculptor to the Medici, exhibition catalog (Edinburgh-London-Vienna) curated by Ch. Avery and A. Radcliffe, Edinburgh, 1978.

K. Lankheit, *Die Modellsammlung der Porzellanmanufaktur Doccia*, Munich, 1982.

Repertorio della scultura fiorentina del Seicento e Settecento, curated by G. Pratesi, 3 vols., Turin, 1993.

R. Spinelli, *Giovan Battista Foggini "Architetto Primario della Casa Serenissima" dei Medici (1652–1725)*, Florence, 2003.

R. Spinelli, "Feste e cerimonie tenutesi a Firenze per le "Felicissime Nozze": nuovi documenti," in *Maria de' Medici (1573–1642). Una principessa fiorentina sul trono di Francia*, exhibition catalog (Florence) curated by C. Caneva and F. Solinas, Livorno, 2005, pp. 130-140.

D. Zikos, "Ercole e le dodici fatiche," in *Giambologna, Gli dei, gli eroi*, exhibition catalog curated by B. Paolozzi Strozzi and D. Zikos, Florence, 2006, p. 175.

Il fasto e la ragione. Arte del Settecento a Firenze, exhibition catalog curated by C. Sisi and R. Spinelli, Florence, 2009.

R. Coppel, in *Brillos en bronce. Colecciones de Reyes*, exhibition catalog Madrid, 2009-2010.

The Barbara Piasecka Johnson Collection. Renaissance & Baroque Masterworks, Sotheby's, London, 8 July 2009.

R. Spinelli, in *Una gloria europea. Pietro da Cortona a Firenze (1637-1647)*, exhibition catalog (Florence) curated by R. Contini and F. Solinas, Cinisello Balsamo, 2010.

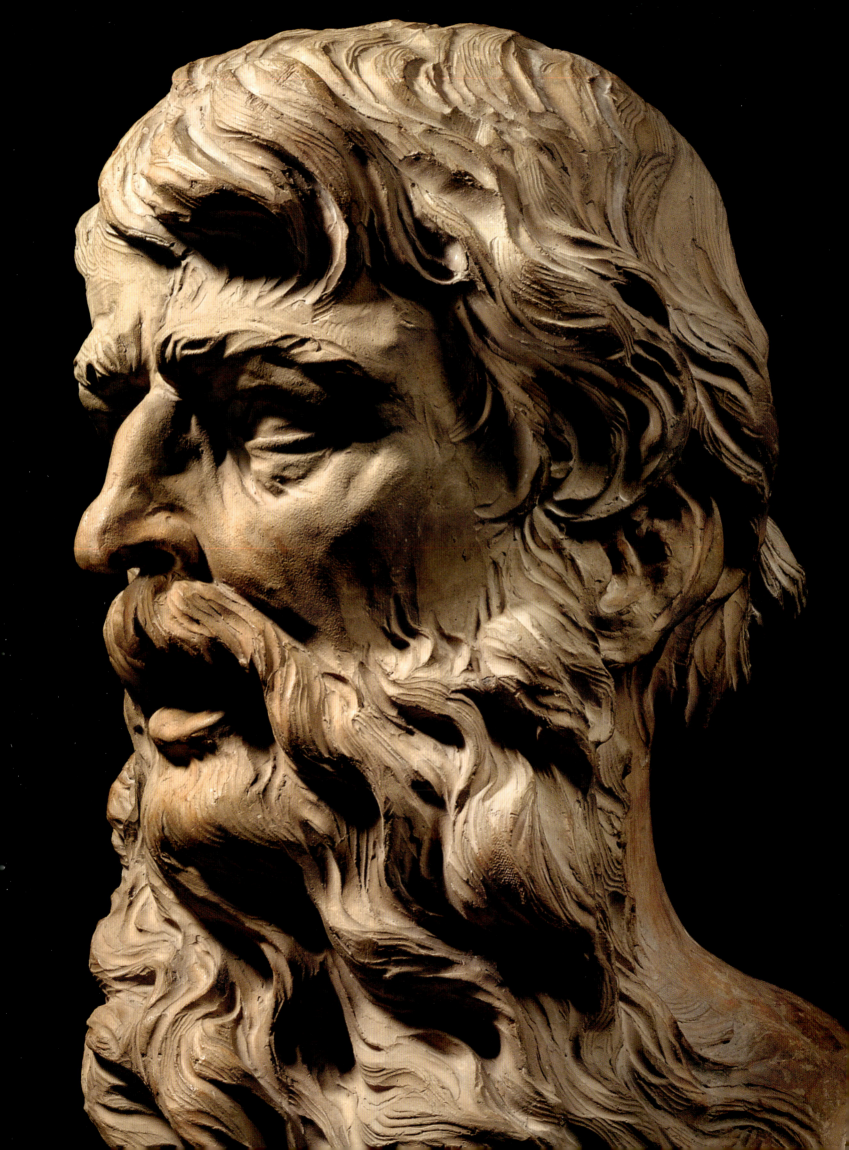

PIERRE
LE GROS

PIERRE LE GROS
BUST OF A MAN

Terracotta, 52 cm. (20 ½ in.) high, circa 1700–1705

Although only recently rediscovered, this monumental male bust, with its long and flowing beard, is one of the most powerful and moving terracotta sculptures to survive from the Baroque period. The extraordinarily vivid and active working of the clay expresses—both on a physical and psychological plane—the tremendous energy of the figure it represents.

The work thus succeeds in creating a forceful naturalistic effect: it depicts the intense presence of a male figure who is already somewhat advanced in years, but still at the height of his vigor and his authority. While we cannot be certain of the specific identity of the figure it represents, there can be no doubt of the type it portrays. With the large and agitated beard, and the mouth open as if in a shout, it conveys the idea of a heroic and powerful figure, whether from Judeo-Christian tradition or classical antiquity. The figure could be one of the prophets of the Old Testament (one thinks of Moses in anger) or one of the Apostles of the New Testament (for example, Saint Paul preaching). Alternatively, it might represent one of the gods from classical antiquity, such as Neptune shown in the moment of "Quos ego" from the *Aeneid*, which was often depicted in Renaissance and Baroque art.

In the absence of a definitive identifying attribute, we cannot determine the exact iconography of the work. But it is also possible that the indefinite iconography could have been part of the conscious strategy of the artist, according to one conceivable hypothesis concerning another fundamental question, equally difficult to answer: that of its original function.

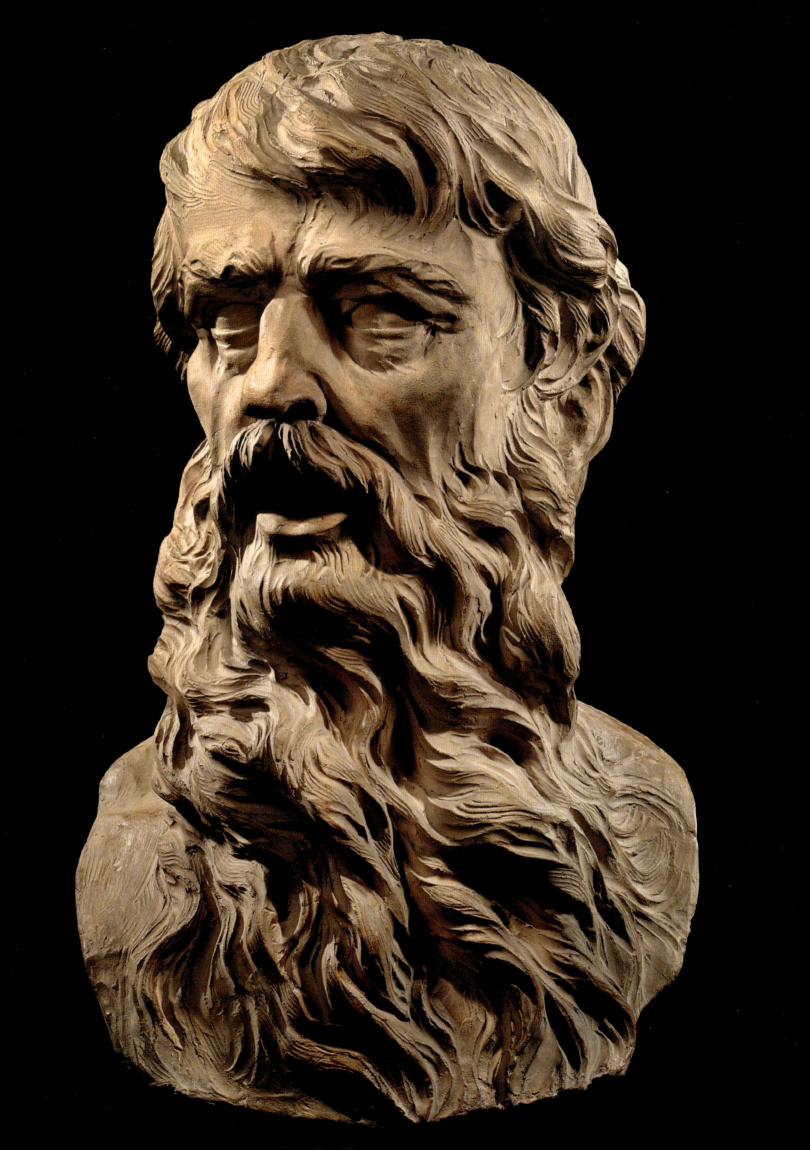

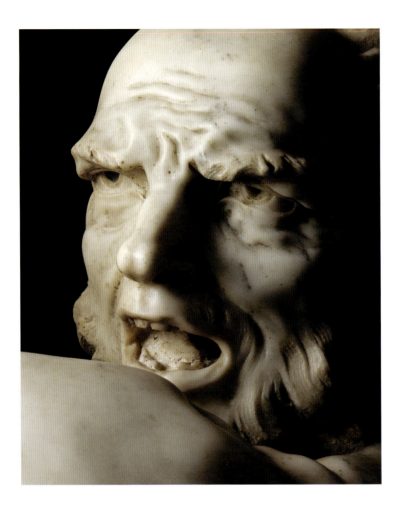

Fig. 1
Pierre Le Gros,
Religion Overthrowing Heresy, detail, Il Gesù, Rome

What was, in fact, the function of this extraordinary sculpture in terracotta? Although conspicuous for the many passages of bravura sketching of the clay, nothing allows us to exclude categorically that it was either a large-scale model for casting of a bronze, or perhaps a presentation model for a marble, made for the approval of a patron (a possibility that we will examine further below). Yet the scale and the format of the sculpture, the outstanding virtuosity of the treatment of the surface, and the indeterminateness of the iconography lead us to propose another possibility: that the sculpture was conceived as an independent and autonomous work of art, made to display the extraordinary technical skill and the complete aesthetic authority of the sculptor. Indeed, the stylistic characteristics of the work also point toward a dating perfectly suitable to the technical mastery and the artistic command presupposed by this hypothesis.

Manifestly, this sculpture is a work of the late Baroque in Rome; even at first glance it is obvious that it must be dated to the period between the last quarter of the seventeenth century and the first quarter of the eighteenth. Not only does the sculpture recall Michelangelo's *Moses*, a canonical work for all Baroque sculptors in Rome, the terracotta also clearly shows evidence of detailed knowledge of the tradition of Roman sculpture in the seventeenth century.

Typologically, the sculpture belongs to the series of powerful "vecchioni" or Old Men that was a standard part of Roman Baroque from Guido Reni and Andrea Sacchi at the beginning of the seventeenth century to Giovanni Battista Gaulli at the end. Perhaps the

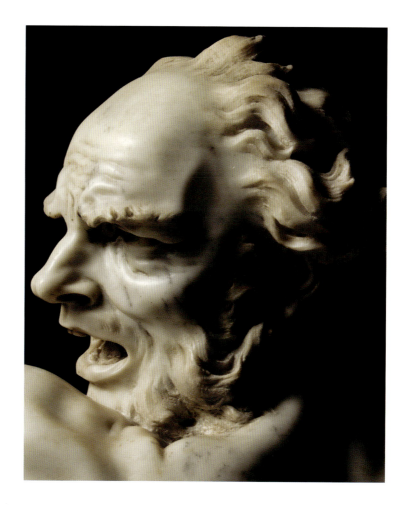

supreme exponent of this tradition was Gianlorenzo Bernini, whose works of this type include the deity in *Pluto and Persephone*, the four Doctors of the Church in the monumental *Cathedra of Saint Peter*, and the deeply moving *Saint Jerome* in Siena.

Stylistically, moreover, the present terracotta shares many traits of the sculptures made by Roman artists in the tradition of Alessandro Algardi. For example, the exceptional and marvelous equilibrium in the terracotta between the elegance of the form and the vibrant energy of the treament would not be conceivable without the precedent of Algardi. Indeed, the present sculpture strongly recalls some of Algardi's works in particular, such as *The Decollation of Saint Paul*, conceived for Bologna in the early 1670s. Manifest as well is the connection of the present sculpture with the series of bearded saints that Algardi made near the end of his career for the Franzone of Genoa.

To find the author of this work, it is necessary to turn to a sculptor who, following in the steps of Algardi, reached the heights of the "hyper-baroque," someone like Pierre Puget or Melchiorre Cafà. Furthermore, the emotive force and the artistic quality of the present terracotta make one think of a sculptor of great accomplishment and importance.

The visionary characterization of the face and the expressive way of making the anatomy of the body disappear under a beard that undulates like a stormy sea strongly recall the stylistic identity of the great French artist, Pierre Le Gros (1666–1719), who, along with Camillo Rusconi, dominated sculpture in Rome around 1700. Indeed, a series of extremely

Fig. 3
Pierre Le Gros, *Tomb of Gregory XV and Cardinal Ludovisi*, detail, Sant'Ignazio, Rome

Fig. 4
Pierre Le Gros, *Tomb of Gregory XV and Cardinal Ludovisi*, detail, Sant'Ignazio, Rome

eloquent and close correspondences help to confirm the attribution of the present sculpture to Le Gros.

Let us begin by comparing it with one of Le Gros's greatest masterpieces, the large marble group of *Religion Overthrowing Heresy*, which is located next to the altar of Saint Ignatius in the church il Gesù, Rome. Widely regarded as one of the key monuments of the late Baroque, it is an outstanding example of Jesuit art patronage. Le Gros won the commission for this monument—his first major commission for an important church in Rome—while still a student, and he had to leave the French Academy where he had been studying in order to take up the project. This was a far-sighted decision: the monument, executed between 1695 and 1699, achieved such a great critical success that it established Le Gros as the new star in the artistic firmament of the city.

Thanks to the scaffolding recently around Le Gros's monument of *Religion Overthrowing Heresy*, it has been possible to study and photograph it with new thoroughness, establishing many points of extremely close correspondence with our terracotta *Bust of a Man*. For example, the face of the allegorical figure of *Hatred* (below the lightening bolts of *Religion*, and never before photographed except in profile) establishes a firm point of understanding Le Gros's style, and it is extremely similar in detail to that of the present terracotta (figs. 1, 2). In the first place, the *ethos* of the face appears the same, animated in both cases by an identical expressive violence. Despite the difference in material, the two heads are nearly interchangeable in many of their parts: for example, the eyes framed by bold eye-

brows that almost pour down onto the eyelids, the large irregular nose, the dramatically open mouth, the forceful gaze, and the large and unnaturally wide eyes.

Possibly even more impressive is the comparison of the lateral views of the two heads: the lines of the profiles, the ferocious eyes, and the deeply incised and shadowed masses of the hair and beard are virtually identical. In sum, the same sense of form, and the same artistic intentions animate the two sculptures.

The view from above of the marble head of *Hatred* permits us to compare the large flowing locks of the hair with those that articulate in a like manner (although obviously with greater freedom) the beard of the terracotta. Even the dramatic hair of the allegory of *Heresy*—a well known example of Le Gros's artistry—can be compared with the beard of the terracotta for the similar combination of some areas that present relatively flat and actively worked surfaces with other areas that instead feature deeply modeled and exuberantly undulating forms that emerge in very high relief.

The hair of the terracotta provides further points of comparison. Characteristic of its treatment are the strands of hair that fall across the forehead in a series of little consecutive curves. This is a stylistic feature that is extremely common in many of the documented works of Le Gros. It is found, for example, in the hair of the little angels (fig. 3) that clamber up the *Tomb of Gregory XV and Cardinal Ludovisi* in Sant'Ignazio, Rome (1709–1713). It is especially interesting to note how Le Gros achieves the same effect in clay through the use of the *cavaterra*, a modeling tool, that he does in marble with the use of the drill.

There are other elements of this tomb, hitherto never photographed up close, that provide extremely telling points of comparison with the present terracotta. It is not difficult to see that the large bearded heads in gilt bronze on the tomb in this monument are a kind of translation into metal of key features of the terracotta (fig. 4). For example, despite the difference in material, the bone structure of the eye-sockets, the protuberant shape of the large nose, the freedom of the lavish beard of the bronze heads appear to be nearly identical with the corresponding components of the terracotta.

Furthermore, a systematic survey of the monumental sculpture of Le Gros shows that the terracotta exemplifies a type that it extremely common in the oeuvre of the sculptor: for example, the profile of the large irregular nose, of the deeply set eyes, and of the wild beard can also be found in two of the heads from the large marble altarpiece dedicated to San Francesco di Paolo and carved between 1716 and 1719 in the church of San Giacomo degli Incurabili, Rome. One also sees the same characteristics in the terracotta head as in the two principal heads in the marble relief of *Tobit Lending Money to Gabael* carved between 1702 and 1705 for the Chapel of the Monte di Pietà, Rome.

Le Gros liked this typology so much he even used it for the work, which perhaps more than any other, secured his success in Rome. I refer to Le Gros's statue of *Saint Thomas*,

Fig. 5
Pierre Le Gros,
Saint Thomas, detail,
San Giovanni in
Laterano, Rome

one of the two sculptures that early in his career the French artist made for the most important sculpture project in Settecento Rome: the series of monumental statues of the Apostles in the niches, designed by Borromini, along the central nave of the Basilica of San Giovanni in Laterano. The head of Le Gros's statue of Saint Thomas (fig. 5), made between 1705 and 1711, clearly belongs to the same physiognomic and stylistic series that we have been examining here.

Comparison of the present terracotta with this statue, too, is illuminating. Although Saint Thomas is bald and turns his head in a different manner, there exist an impressive number of corresponding elements, from the fiery eyes to the open mouth, the flowing beard, and the outline of the profile.

The points of similarity are so numerous as to lead us even to wonder if the present terracotta could have been made as the large-scale study for the head of *Saint Thomas*. In that case it would be necessary to posit that this large terracotta goes back to a phase in the design of the work that precedes the preparatory *bozzetto*, today in the Los Angeles County Museum of Art. Although closer in design to the finished marble, that statuette displays many points of comparison with our terracotta. This possibility, of course, can only remain a hypothesis.

Given the numerous strong and clear comparisons with the documented works of the artist, there can be no doubt that the present extraordinary work is clearly by Pierre Le

Gros. Moreover, the many correspondences with works made in the final years of the Seicento and at the beginning of the Settecento suggest that the date of this new masterpiece must belong to this same period of exceptional creativity in the artist's career.

The rediscovery of this extraordinary sculpture is not only a major addition to the catalogue of Pierre Le Gros, but also to the corpus of late Roman Baroque sculpture.

Tomaso Montanari

BIBLIOGRAPHY

Malcolm Baker, "That 'most rare Master Monsu Le Gros' and his Marsyas," *The Burlington Magazine*, 127, 1985, pp. 702–707.

Gerhard Bissell, *Pierre Le Gros 1666–1719*, Reading, 1997.

Michael Conforti, "Pierre Legros and the Role of Sculptors as Designers in Late Baroque Rome," *The Burlington Magazine*, 119, 1977, pp. 557–561.

P. d'Espezel, "Notes historiques sur l'oeuvre et la vie de Pierre II Le Gros," *Gazette des Beaux Arts*, n.s. 5, 12, 1934, pp. 5–16, 149–160.

Robert Engass, *Early Eighteenth-century Sculpture in Rome*, 2 vols., 1976, pp. 42–3, 49–51, 124–48, pls. 93–146.

Cristiano Giometti, *Domenico Guidi 1625–1701. Uno scultore barocco di fama europea*, Rome, 2010, p. 322.

Francis Haskell, "Pierre Legros and a Statue of the Blessed Stanislas Kostka," *The Burlington Magazine*, 97, 1955, pp. 287–91.

Eugene Müntz, "Recherches et documents inédites sur Pierre Legros," *Nouvelle Archives de l'Art-Français*, 1876, pp. 354–58.

Niccolo Pio, "Pietro Le Gros" (1724), in Eugene Müntz, ed., *Nouvelle Archives de l'Art Francais*, 1874–75, pp. 199-201.

François Souchal, *French Sculptors of the 17th and 18th centuries*, Oxford, 1984, esp., vol. III, pp. 273–299.

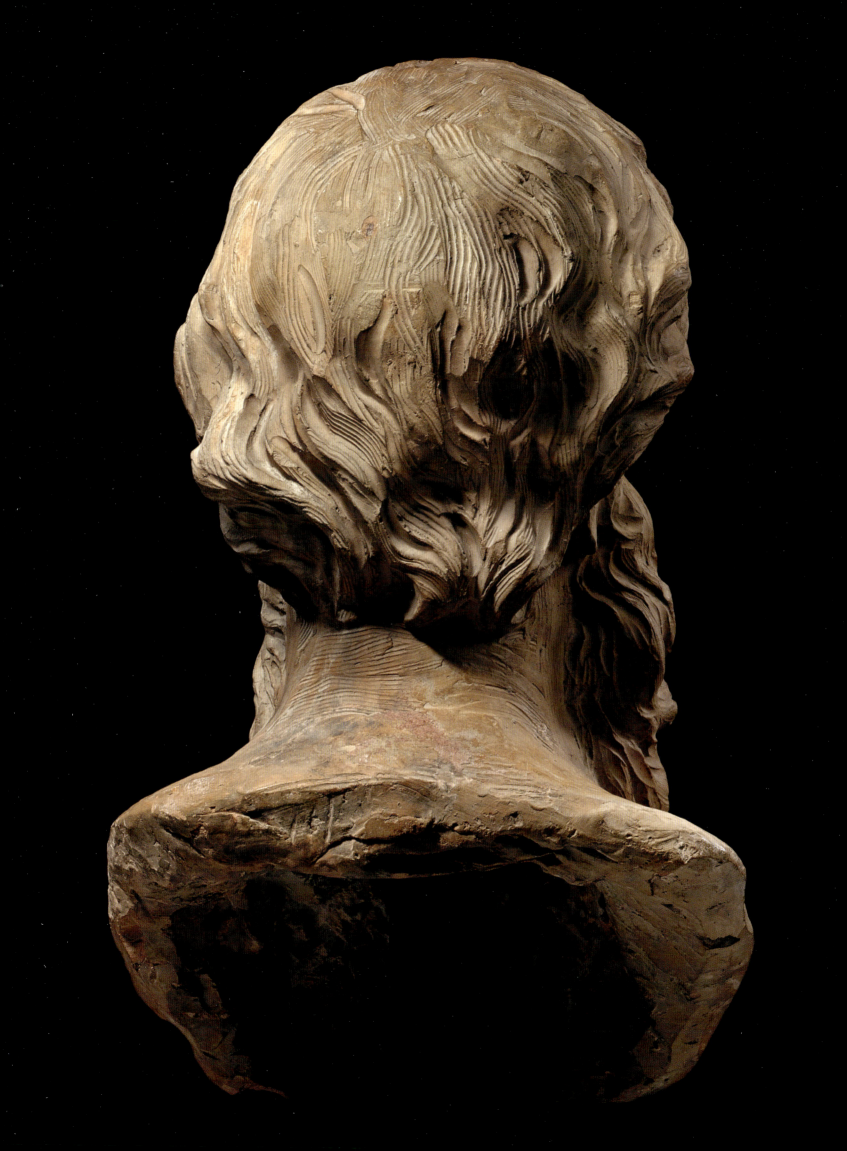

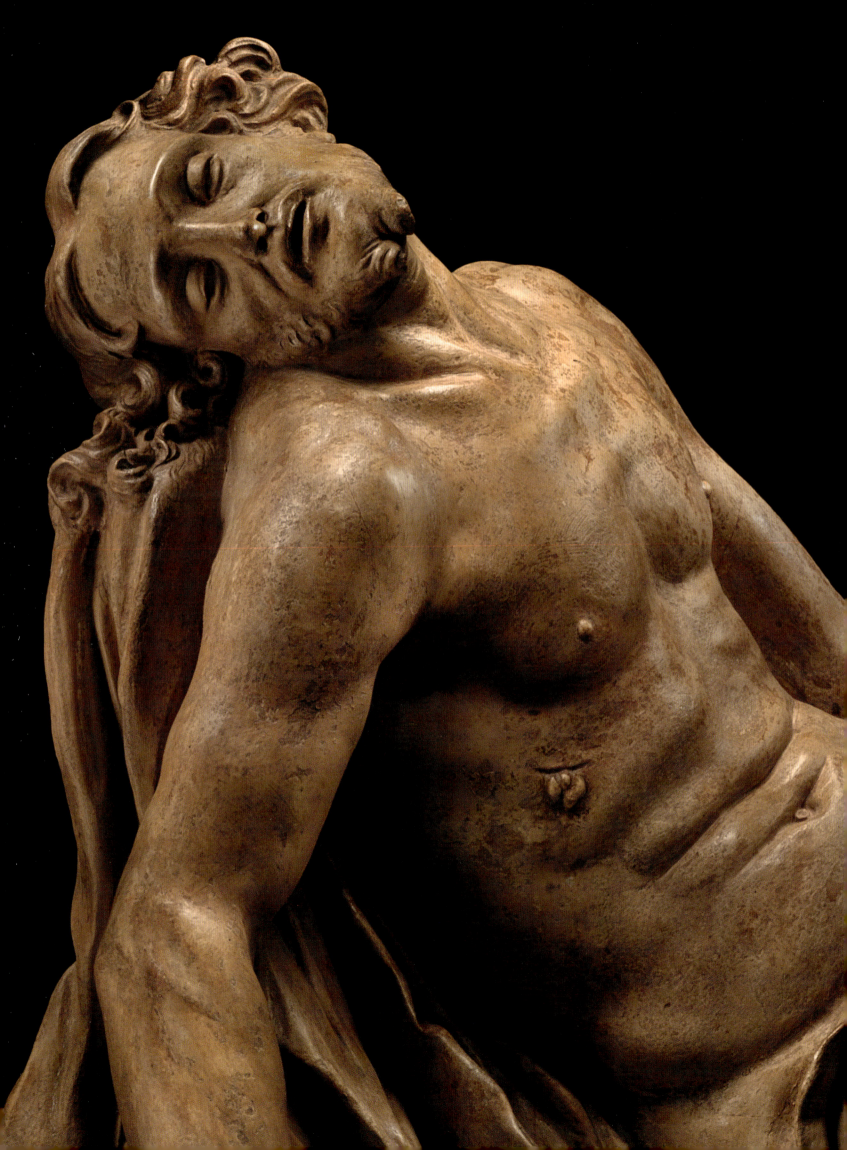

GIUSEPPE
MAZZUOLI

GIUSEPPE MAZZUOLI
DEAD CHRIST

Terracotta, 42 x 61 x 32 cm. (16 $^1/_2$ x 24 x 12 $^1/_2$ in.), circa 1670–1680

In the present terracotta, the characteristics of the face, framed by a mass of thick curls, and the lively and jagged movement of the drapery evoke seventheenth-century Rome, dominated by Bernini. Indeed, the sculpture should be attributed to one of the most important followers of Gian Lorenzo, the Sienese artist Giuseppe Mazzuoli (1644–1725). Following his early training in Siena, Mazzuoli entered the workshop of Ercole Ferrata in Rome during the 1660s where the Maltese sculptor Melchiorre Cafà (died 1667) was also working at the time. Mazzuoli soon joined Bernini's circle, collaborating on the Altar of the Sacrament and sculpting the *Charity* for the Monument to Alexander VII in Saint Peter's. The elder Bernini decisively influenced the style of our sculptor, who went on to develop in original ways the teachings of this master for almost half a century.

Around 1670 Mazzuoli began an independent practice that saw him execute numerous works principally for the churches of Siena, Rome and Malta. Among these the most important include the *Apostles* for the Duomo of Siena (1679–1692; now at the Brompton Oratory in London), the *Baptism of Christ* for the high altar of San Giovanni in Valletta (1703) and the *Saint Philip* for San Giovanni in Laterano in Rome (1715). No less important were his works for private patrons such as his *Adonis* (Saint Petersburg, Hermitage), the relief with the *Holy Family* (Cleveland Museum of Art) and the Cleopatra (Lisbon, Colonial Garden), not to mention the portrait busts. The catalogue of the sculptor also contains a rich collection of terracottas which are preserved in several American museums (see Butzek 1988; Draper 1994; Bacchi 1996).

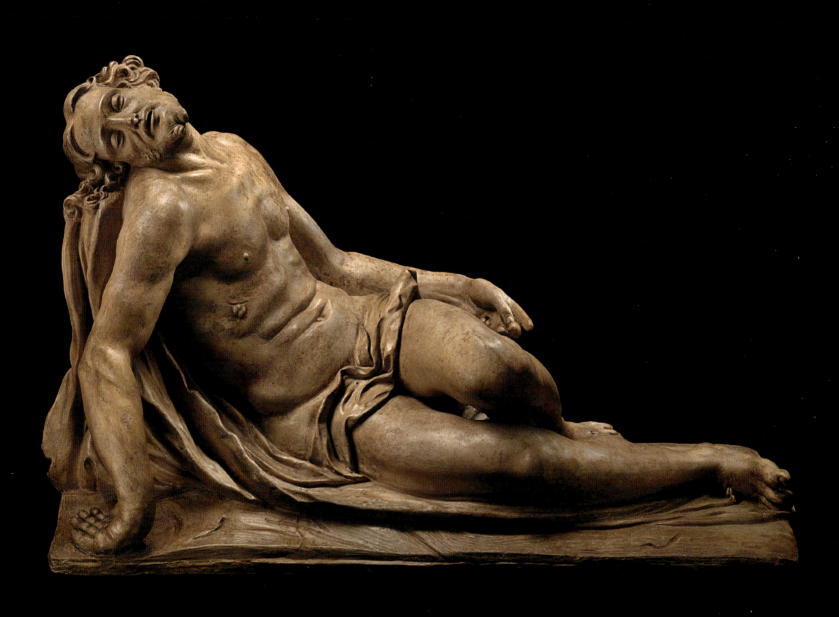

The attribution of the present work can be confirmed by comparison with the relief of *Dead Christ* in the church of Santissima Annunziata in the hospital of Santa Maria della Scala, Siena (fig. 1). Made around 1670 (Pansecchi 1959, pp. 34–35), the relief was executed in Rome and represents, according to the testimony of Leone Pascoli (p. 931), the first independent work of the sculptor. The similarities of the two sculptures are manifest: compare, for example, the pose of the left arm, with the hand resting on the leg, the tremulous rendering of the drapery or the heroic anatomy of the body, shown slack and soft in death. In both works we can also observe a beautiful resolution in the composition (which refers to the work of Ferrata and Algardi), and aspects that instead show the influence of Bernini: this can be read not only in the nervous movement of the sheet, but also in the typology of Christ's face which, especially in the terracotta, refers explicitly to that of the bronze *Crucifix* in Saint Peter's. The pose of Christ in Mazzuoli's sculpture is like that of the *Beata Ludovica Albertoni* by Bernini.

Characterized by an extremely remakable finishing of the surface, the terracotta may be regarded as either a model for a three-dimensional statue or, more likely, as an autonomous group intended for private devotion. There are numerous reliefs in terracotta attributed to Giuseppe and his circle in which the dead Christ is seen either alone or accompanied by Mary or the Angels (cfr. Pansecchi 1959, p. 35; Butzek 1988, pp. 85–87; Sisi in Gentilini-Sisi 1989, pp. 268–271; 322–323; 347–353). The sculptor also made several statues of the theme. In an inventory of the workshop by the great-grandson of the sculptor, Giuseppe Maria Mazzuoli, written in 1767, we find for example "a larger-than-life dead Christ by the above mentioned Giuseppe" (Butzek 1988, p. 96, n. 160). Pascoli also records how Giuseppe "had…made a little marble Pietà, that he kept on top of a table in the room, and to which he was constantly making kneeled prayers. He was approached several times to sell it and although he had been offered two hundred crowns he would never give it up. It is made so naturally and is so masterfully worked that it moves all who see it to devotion" (1736 ed. 1992, p. 935). In the past it was thought that the sculpture admired by Pascoli was identifiable with the version in the Chigi Saracini collection in Siena (29 x 58,5 x 30,5 cm), now deemed a workshop replica (cfr. Sisi in Gentilini-Sisi 1989, pp. 322–323). The composition of the Sienese marble also appears in a bronze now in Raleigh at the North Carolina Museum of Art. Following the relief in Santa Maria della Scala, the dead Christ became a favorite theme of our sculptor who realized various versions of it, in diverse materials, throughout his career. In the absence of the orignal mentioned by Pascoli, the current state of knowledge does not permit us to say which of the extant sculptures most closely resembles the marble that Mazzuoli jealously guarded in his home.

Without dwelling on the Morellian details, we must still mention how the comparison of the statue with sculptures of other themes by Mazzuoli in his youth not only allows us to confirm its authorship but also to suggest a date close to the decade 1670–1680. For example, in the *Saint John the Baptist* in the church of Gesù e Maria in Rome, datable to around 1680, the face of the saint is almost exactly like that of the Christ in terracotta; furthermore, both works clearly show the strong influence of Bernini in their treatment

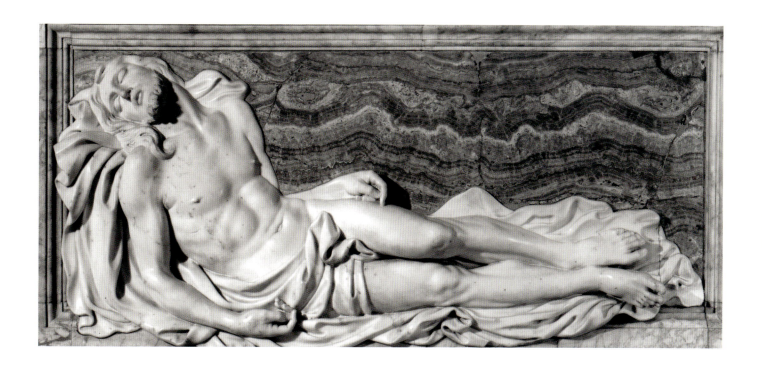

of the features. Not long after the elder artist worked with particular devotion on the theme of Christ, Mazzuoli undertook to elaborate his own original interpretation of Christ deposed from the cross, "so masterfully worked that it moves all who see it to devotion" (Pascoli).

Fig. 1
Giuseppe Mazzuoli, *Dead Christ*, Santa Maria della Scala, Vienna

Andrea Bacchi

BIBLIOGRAPHY

Andrea Bacchi, *La scultura del '600 a Roma*, Milan, 1996, pp. 821-823.

Monica Butzek, "Die Modellsammlung der Mazzuoli in Siena," *Pantheon*, 1988, pp. 75-102.

Monica Butzek, "Giuseppe Mazzuoli e le statue degli apostoli del Duomo di Siena," *Prosepettiva* 61, 1991, pp. 75-89.

James David Draper, "Some Mazzuoli Angels," *Antologia di Belle Arti,* 1994, n.s., 48-51, pp. 59-63.

Giancarlo Gentilini and Carlo Sisi, *Collezione Chigi Saraceni: Le sculture*, 2 vols, Florence, 1989, pp. 268-328.

G. Pansecchi, "Contributi a Giuseppe Mazzuoli," *Commentari* 10, 1959, pp. 33-43.

L. Pascoli, *Vite de' pittori, scultori ed architetti moderni* (1730-36), ed. V. Martinella, Perugia, 1992, pp. 931-935.

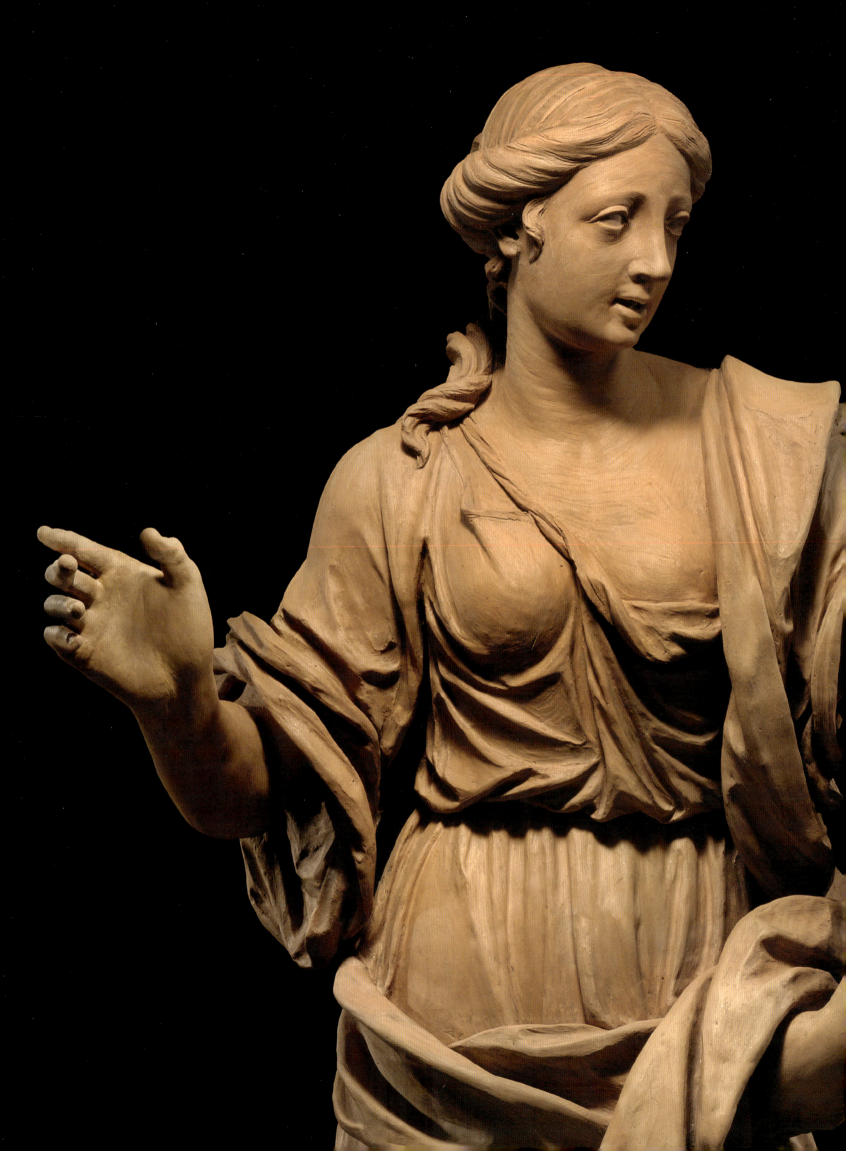

GIUSEPPE
PIAMONTINI

GIUSEPPE PIAMONTINI
FIGURE OF A GIRL

Terracotta, height 110 cm. (43 $\frac{1}{4}$ in.) high, circa 1689–1692

This lovely statue, possibly an Olympian deity, is a significant addition to the oeuvre of Giuseppe Piamontini (Florence 1663–1744), one of the major figures of Tuscan art of the late Medicean period. Piamontini was particularly favored by the Medici who saw to his artistic education by sending him to study at the Accademia in Rome. This institution was, from 1678 onward, intended by Grand Duke Cosimo III to effect a revival of Tuscan art in a modern and fully Baroque style.

Piamontini, born in January 1663, began his career in Florence in the orbit of Foggini, before spending five years in the Eternal City, where he arrived in November 1681. The eighteen-year-old sculptor established himself from the start as a star pupil of the two masters, Ercole Ferrata and Ciro Ferri, appointed by Cosimo to guide young artists in the study of "Anticho grecho," an ideal style of classical purity. Under these teachers, hand-picked by the Tuscan prince, Piamontini followed a rigorous educational program and immersed himself in classical culture, especially as seen through the filter of Pietro da Cortona (already known to Piamontini through his Florentine works), Algardi and Duquesnoy. He also displayed an interest in more modern artists, above all Domenico Guidi and Antonio Raggi.

Evidence of his early activity is a document from October 1682, when Piamontini exhibited a relief, possibly the *Nativity* that was sent the next month to Florence to be shown to the sovereign. The following year, in a crescendo of incessant work, the sculptor was engaged in modeling a relief in clay of *Jove*. In December he worked on an unspecified statue in

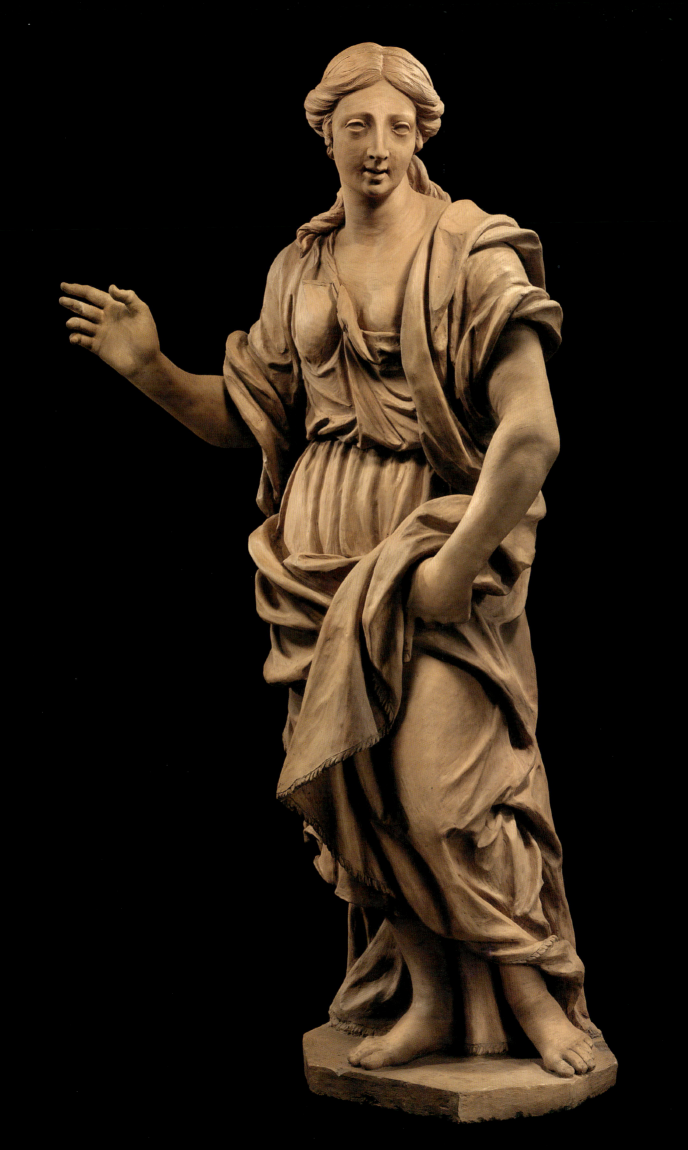

Fig. 1
Giuseppe Piamontini,
Fortune, Feroni
Chapel, Santissima
Annunziata, Florence

marble, and in May 1685 he participated, along with some other pensionati from the Palazzo Madama, in the execution of glazed terracotta reliefs for a *'Via Crucis'* that the Grand Duke wished to have made for the Spanish Alcantrini, a reformed Franciscian order brought to Tuscany by the Grand Duke and installed in a monastery built for them near his much-loved villa of the Ambrogiana in Montelupo. The terracotta reliefs were executed under the direction of Ciro Ferri, who designed the scenes of the Passion of Christ.

Piamontini distinguished himself in Rome through his talent and industry—the Medicean envoy to the city, Giovan Battista Mancini, called him "an angel in everything" (Lankheit 1962, p. 265, doc. 230). Upon return to Florence Piamontini won many prestigious commissions. The most important came from either the Medici, other prominent aristocratic families, or major religious orders. In 1687, just one year after his return, we can date the alabaster *Dead Christ* now in the Palazzo Pitti. A smaller version in terracotta is conserved in the Church of Michele e Gaetano in Florence. The following year was the occasion of an important public work, the *Saint John the Baptist*, destined for the Florence Baptistery. During 1688 and after, he solidified his relationship with Grand Prince Ferdinando de'Medici who continued to reward him with significant commissions until 1695. (Spinelli 2007, p. 181.) These include large reliefs, such as the series of four female busts carved in 1689, three of which are probably those now conserved in the great staircase and apartments of the Palazzo Pitti, and elegant groups in bronze. In 1691–1692 Piamontini made the beautiful allegorical figure of *Fortune* (fig. 1) and the sculptural decoration of the chapel erected for Francesco Feroni in the basilica of Santissima Annunziata in Florence.

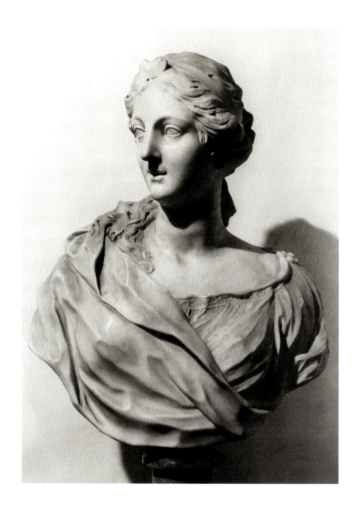

It is precisely with these later works, and with others datable to the first half of the artist's Florentine period—all idealized images of the female form—that the present statue finds numerous points of comparison. These include the typology of the face, characterized by a small open mouth, a perfect nose, a slightly dreamy expression, and half-closed eyes. This expression brings it close to both the marble Diana at the Pitti (fig. 2) and to the female figure in the Pratesi collection (S. Bellesi, in *Il fasto e la ragione* 2009, p. 66, no. 2) as well as to the *Diana* in the beautiful terracotta formerly with Daniel Katz Ltd. in London. The *Figure of a Girl* also shares with the above works a distinctive hair style, in which the hair is tied up, with tresses then falling loosely on the shoulders in long, undisciplined locks. The present work was first attributed to Piamontini in an expertise in December 2008 by Sandro Bellisi, the author of the most recent monograph on the artist. There can be no doubt about the justice of this identification.

A dating of this work at the end of the seventeenth century is supported by the elegant, classicizing style of the clothing. The transparent folds of her dress fall lightly over the well-rounded body, and contrast with the heavier material of the mantle, whose pendulant folds offer the sculptor an opportunity to display his virtuosity in creating chiaroscuro effects in the drapery enfolding the girl's thighs. Her sleeves are a whirlwind of drapery, and around her legs the cloth falls in undulating folds, where her mantle comes to rest. This distinctive style is also seen in the Feroni *Allegory of Fortune* and is particularly evident in the beautiful bronze Juno, a youthful work in the Ashmolean Museum in Oxford (cfr. *Repertorio della scultura fiorentina*, 1993, III, fig. 426) and in a female bust in the Palazzo

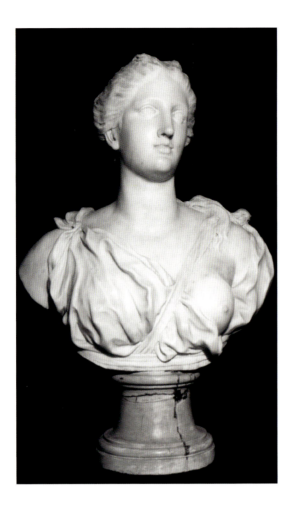

Fig. 3
Giuseppe Piamontini,
Female Bust, Palazzo
Pitti, Florence

Pitti (fig.3). Piamontini's other interpretations of Juno, in terracotta and in stucco, at one time in the collection of the Heim Gallery in London and in the Vignamaggio villa in Chianti (ibid, figs. 428–429) also exhibit this characteristic treatment of the drapery.

Piamontini was masterly in the modeling of clay and the present sculpture perfectly illustrates his felicitous use of the material. The girl's hands are rendered delicately and naturalistically; her feet are poised in mid-step, with one anchored to the earth, the other lifted gracefully in counterpoint to the right arm, which is stretched toward the viewer; her figure is animated by a fluid and natural movement, as she tosses her head, smiling.

The high degree of finish of the forms seem to rule out the possibility of this being a *modello* for a work in marble or bronze. Instead, the scale of the figure, the lively working of the surface, and the arcadian mood suggest that this was a fully-developed work, intended for an outdoor setting, most likely a niche in a garden.

Riccardo Spinelli

BIBLIOGRAPHY

G. Piamontini, *Autobiografia*, in Lankheit 1962, p. 232, doc. 46.

K. Lankheit, *Florentinische Barockplastik. Die Kunst am Hofe der letzten Medici 1670–1743*, Munich, 1962, pp. 165–167.

Gli ultimi Medici. Il tardo barocco a Firenze, 1670–1743, catalogo della mostra (Detroit-Firenze), Florence 1974.

M. Visonà, "La Via Crucis del Convento di San Pietro d' Alcantara presso la Villa l'Ambrogiana a Montelupo Fiorentino," in *Kunst des Barock in der Toskana. Studien zur Kunst unter den letzten Medici*, Munich, 1976, pp. 57–69.

M. Visonà, "Cappella Feroni nella Santissima Annunziata", in *Cappelle barocche a Firenze*, ed. M. Gregori, Cinisello Balsamo 1990, pp. 221–248.

S. Bellesi, "L'antico e i virtuosismi tardo barocchi nell'opera di Giuseppe Piamontini", *Paragone*, XLII, nuova serie, n. 28 (497), 1991, pp. 21–38.

Repertorio della scultura fiorentina del Seicento e Settecento, ed. G. Pratesi, 3 vols., Turin, 1993, I, pp. 55–56, 93–94.

R. Spinelli, "La Caduta dei giganti di Giuseppe Piamontini," in *Palazzo Spini Feroni e il suo museo*, ed. di S. Ricci, Milano 1995, pp. 197–207.

M. De Luca Savelli, "Bronzetti e marmi del Gran Principe Ferdinando nell'inventario del 1713," in *Arte collezionismo conservazione. Scritti in onore di Marco Chiarini*, ed. N. Barbolani di Montauto, Florence, 2004, pp. 71–78.

D. Zikos, *Giuseppe Piamontini. Il Sacrificio di Isacco di Anna Maria Luisa de' Medici, Elettrice Palatina*, Milan, 2005.

La principessa saggia. L'eredità di Anna Maria Luisa de' Medici Elettrice Palatina, exhibition catalog (Florence, 2006–2007) ed. Casciu, Livorno 2006.

S. Bellesi, *I marmi di Giuseppe Piamontini*, Florence, 2008.

Il fasto e la ragione. Arte del Settecento a Firenze, exhibition catalog, ed. C. Sisi e R. Spinelli, Florence, 2009.

Brillos en bronce. Colecciones de Reyes, exhibition catalog (Madrid 2009–2010), *commissari* R. Coppel e M. J. Herrero Sanz, *coordinamento* di I. Morán Suárez, Madrid 2009.

R. Contini, in *Una gloria europea. Pietro da Cortona a Firenze (1637–1647)*, exhibition catalog (Florence) ed. R. Contini and F. Solinas, Cinisello Balsamo 2010, pp. 162–163, nos. 41–42.

R. Spinelli, in *Una gloria europea*, 2010, pp. 160–161, n. 40.

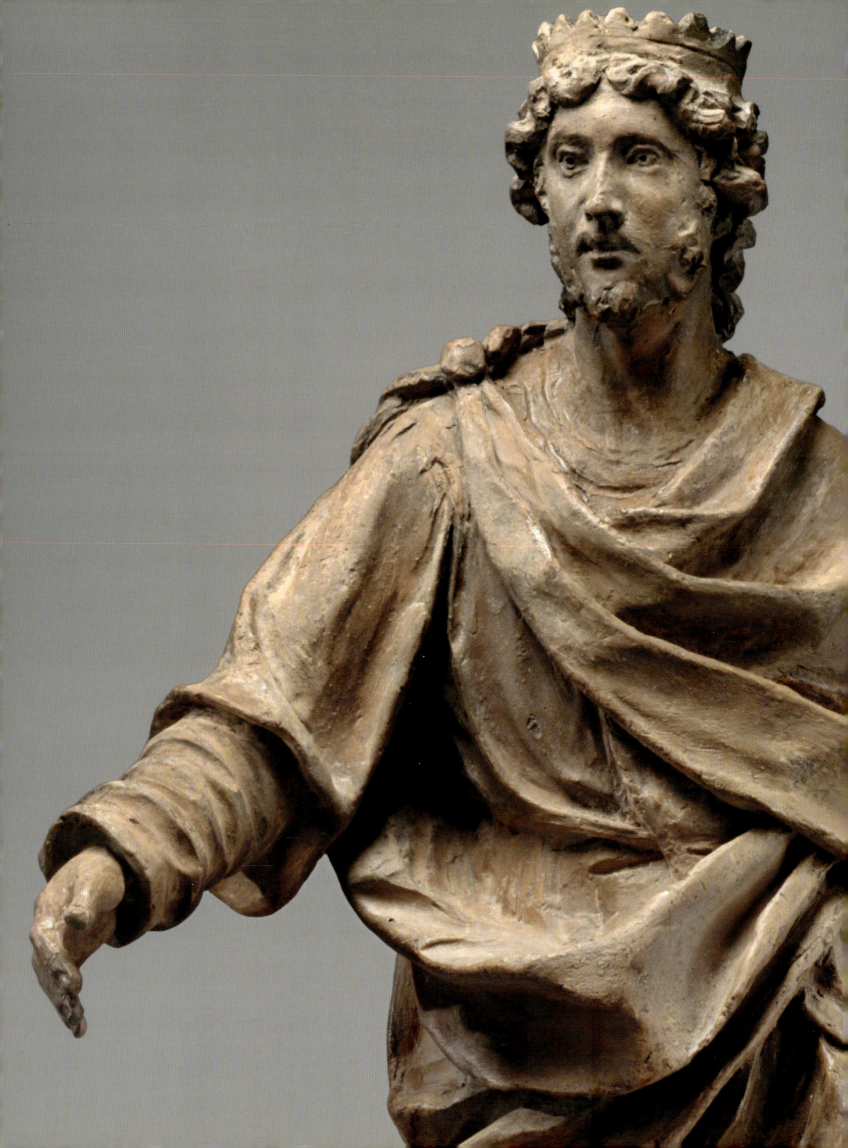

GIOVACCHINO FORTINI

GIOVACCHINO FORTINI
KING DAVID

Terracotta, Height 37.5 cm (14 ¾ in.) high, circa 1714–1716

This beautiful terracotta figure of David is signed with the artist's monogram, "GF" on the back of Kind David's lyre. The scupture was discovered by Sandro Bellesi and published in his monograph on Giovacchino Fortini, co-authored with Mara Visonà. Bellesi's monograph, using contemporary sources and archival documents, has brought us a fuller understanding of the stature and significance of Fortini (1670–1736), one of the most important figures in Florentine sculpture at the end of the seventeenth century and the beginning of the eighteenth century.

Fortini was born in 1670 into a family of marble carvers from Settignano, which occasioned his first steps into the art world. He then passed under the tutelage of Carlo Marcellini and later, Guiseppe Piamontini. His artistic training was unorthodox, as it was not circumscribed by the classical curriculum imposed on students in Rome by Grand Duke Cosimo III following the formation in 1673 of the Medicean Academy in Rome. This institution was established by the young sovereign with the principal goal of educating Tuscan artists in the modern language of the late Baroque.

This lack of institutional training, which was a feature in the education of the other major artists of the period – such as the sculptors Giovan Battista Foggini, Massimiliano Soldani Benzi, Giuseppe Piamontini, and the painter Anton Domenico Gabbiani – allowed Fortini to pursue a path of his own, outside academic orthodoxy. This contributed to the heightened naturalism of his portrait sculptures in which he relentlessly pursued a lifelike depiction of his subjects. His untraditional education also allowed him to develop an interest

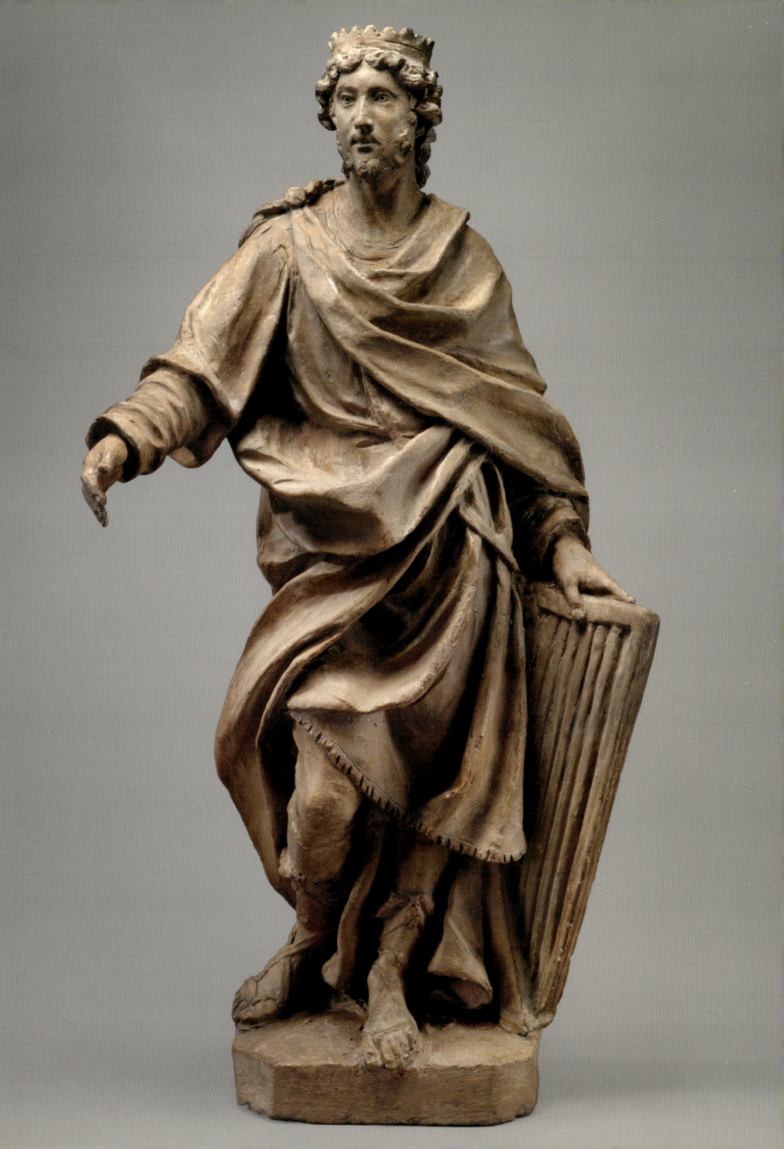

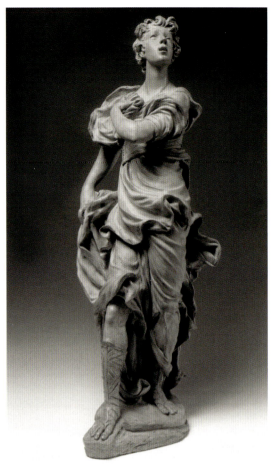

Fig 1
Giovacchino Fortini, *Male figure*, private collection

Fig 2
Giovacchino Fortini, *Study for Reliquary of Saint Sigismund*, Museé du Louvre, Paris

in Tuscan Mannerist sculpture. Thus, the young artist's works already show his unique figural lexicon: elongated figures, exaggerated emotions, unconventional forms, elegant drapery, and lively rhythms.

A master of expressiveness, Fortini makes use of these elements, evocative of Florentine Mannerism, from the beginning of his career. They are evident in the funerary monument of Philipp Bertram Degenhart Joseph von Hochkirchen, in the cathedral of Cologne, made between 1701–1703 (M. Visonà, in Bellesi-Visonà 2008, II, pp. 61–63, n. 16). The superb figure of the baron is here shown in a truly unconventional pose: he is affecting an aristocratic stance, and yet the tone is so ironic that the figure appears almost like a youthful swain.

Despite the *David*'s small scale, and the evident speed of its making, it is a work that is magisterial in its perfectly calibrated proportions, and the fluid rhythm with which David strides towards the viewer. It appears to be a preparatory sketch for a major work, albeit one for which as yet there is no known documentation. The drapery of David's cloak creates dramatic chiaroscuro and adds volume to his slender figure. And it is evident from the unfinished state of the back, where the folds of the mantle die out and disappear, that this was a model for a large sculpure in a niche.

The majesty of this pose, along with the expressiveness of his features—marked by an attentive, almost questioning gaze—contribute to the figure's regal air. The artist interprets

David according to his description in the Book of Samuel, where the future king plays his lyre to cure Samuel's melancholy (*I Samuel*, 16, 14–22.) Here David is described as "a mighty valiant man, and a man of war, and prudent in matters, and a comely person, and the LORD is with him" (King James Translation).

Fortini's vigorous tool-work is evident both in the folds of the light garment, and in the ample cloak that envelopes the figure, leaving uncovered only part of the legs and feet. Also typical of Fortini are the elegance and liveliness of David's stride, the elongated body, the sinuous curve of his pose, and the alert and lively expression of the face. All of these characteristics clearly relate our David to the allegorical figures of *Charity and Purity* made around 1714–15 by Fortini for the church of San Firenze in central Tuscany (S. Bellesi, in Bellesi-Visonà 2008, II, pp. 151–154, nos. 68–69). Likewise the present work resembles another beautiful preparatory model in terracotta of a draped male figure, possibly an angel (fig. 1), which I published some years ago (R. Spinelli, in *Terrecotte italiane* 1997, pp. 40–47) and which was subsequently accepted by other scholars (see Bellesi-Visonà 2008, II, pp. 147–148, no. 66).

In this other work we find additonal elements analogous to those of our terracotta. Among these are the elongated feet, slightly out of scale, and shod with sandals, on which Fortini lingered over the tactile quality of the leather straps; hair worked into ruffled and unruly locks; the fluttering drapery; and the different levels of finish given to different areas of the statue. The skin is smoother from the repeated passage of the artist's fingers over the still-soft clay during the modeling, while the clothing, hair and crown are rougher and less delicately worked. Also comparable is the artist's attention to the sensitive use of light, and to the poetic evocation of the figure's regal character.

In tracing the history of the *King David* to around 1715, Sandro Bellesi—to whom we owe the careful critical analysis of the work—observed significant parallels with other roughly contemporaneous male figures, and indicated convincing similarities for the figure of the king with that of Saint Sigismond on the saint's reliquary made by the Grand Ducal workshop from a design of Giovan Battista Foggini in 1719 (fig. 2); (for the reliquary, see also E. Nardinocchi, in *Il fasto e la ragione* 2009, pp. 76–77, no. 7). Bellesi further noted that these two examples of ancient kings have a shared lineage in Roman models such as the equestrian figures of *Constantine* and *Charlemagne*, works by Gian Lorenzo Bernini and Agostino Cornacchini respectively, intended for Saint Peter's, and the Attila in Algardi's large relief in the interior of the Vatican basilica.

Riccardo Spinelli

BIBLIOGRAPHY

Sandro Bellesi and Mara Visonà, *Giovacchino Fortini*, 2 vols, Florence, 2008, pp. 164–165, no. 76.

List of Contributors

Andrea Bacchi is Professor of Art History at the Università di Trento and the author of many publications, including *Scultura del '600 a Roma*; and *La Scultura a Venezia da Sansovino a Canova*. Among the exhibitions he has recently organized are (with Luciana Giacomelli) *Rinascimento e passione per l'antico. Andrea Riccio e il suo tempo*; and (with Catherine Hess and Jennifer Montagu) *Bernini and the Birth of Baroque Portrait Sculpture*.

C.D. Dickerson III is Curator of European Art at the Kimbell Art Museum. His publications include *Bernini and Before: Modeled Sculpture in Rome*; *Raw Painting: The Butcher's Shop by Annibale Carracci*, and "The 'Gran Scuola' of Guglielmo della Porta, the Rise of the 'Aurifex Inventor', and the Education of Stefano Maderno." He was co-curator, with Richard Bretell, of the exhibition *From the Private Collections of Texas: European Art, Ancient to Modern*.

Marc Fumaroli is Professor Emeritus at the Collège de France, and the former director of the Académie française. The author of more than twenty books on European literature, art, and culture, he won the prestigious Balzan Prize (often considered the equivalent of the Nobel for the humanities) in 2001.

Davide Gasparotto is Senior Curator at the National Gallery of Parma. His main fields of interest are Italian sculpture and decorative arts of the Renaissance and the survival of the classical tradition in western art. He worked on Valerio Belli (2000), Giambologna (2005 and 2006), Riccio (2007, 2008 and 2010). He organized (with Filippo Trevisani) the exhibition *Bonacolsi l'Antico. Uno scultore nella Mantova di Andrea Mantegna e di Isabella d'Este*, held at the Palazzo Ducale of Mantua in 2008.

Giancarlo Gentilini is Professor of Art History at the Università di Perugia, and the author of *I Della Robbia. La scultura invetriata nel Rinascimento*; and many other publications on Renaissance art, including (with Carlo Sisi) *Collezione Chigi Saracini. La scultura. Bozzetti in terracotta, piccoli marmi e altre scultura dal XIV al XX secoli*. The exhibitions he has curated or collaborated on include *I Della Robbia e l "arte nuova" della scultura invetriata*; *La scultura al tempo di Mantegna*; and *Rinascimento e passione per l'antico. Andrea Riccio e il suo tempo*.

Tomaso Montanari is Professor of Art History at the Università degli Studi di Napoli "Federico II." He is the author of *Gian Lorenzo Bernini; Velazquez e il ritratto*; and many other works. He organized the exhibition *Bernini pittore* at the Palazzo Barberini; and co-curated *I marmi vivi. Bernini e la nascita del ritratto barocco*.

Riccardo Spinelli is a leading expert in the visual arts of the Medicean and late Medicean periods. Among the many works he has published and exhibitions he has organized on this subject are *L'arme e gli amori* at the Palazzo Pitti, *Fabrizio Boschi* at the Casa Buonarroti, *Il fasto e la ragione* at the Uffizi, and *Oltre la scuola senese*. In 2003 his monograph *Giovan Battista Foggini* won the Salimbeni Prize for the History and Criticism of Art.

Acknowledgements

We are deeply grateful to the many friends and colleagues who have helped us in the discovery, study and presentation of these works and who have shared our enthusiasm for Renaissance and Baroque sculpture: Denise Allen, Andrea Bacchi, Jane Bassett, Sandro Bellesi, Francesca Bewer, Bruce Boucher, Francesco Caglioti, Gabriele Caioni, Anna Coliva, Kathleen Weil-Garris Brandt, C.D. Dickerson, David Ekserdjian, Marc Fumaroli, Leslie Gat, Giancarlo Gentilini, Flavio Gianassi, William Hood, Alexander Kader, Walter Kaiser, Volker Krahn, Alison Luchs, Tomaso Montanari, Tova Ossad, Nicholas Penny, Joan Pope, Anthony Radcliffe, Patricia Rubin, Anthony Sigel, Frits Scholten, Riccardo Spinelli, Richard Stone, Anne Markham Schulz, Margi Schwartz, Mark Weil and Adam Williams.

In most cases the illustrations have been made from photographs and images provided by the owners or custodians of the works. Those figures for which further credit is due are listed below.

p. 15 Andrew Butterfield

p. 16 fig. 4 © Antonio Quattrone; fig. 5 Andrew Butterfield

p. 24 C. D. Dickerson

p. 26 Foto Marburg

pp. 28–29 Andew Butterfield

p. 30 Foto Marburg

pp. 96–98 © Zeno Colantoni